Memphis

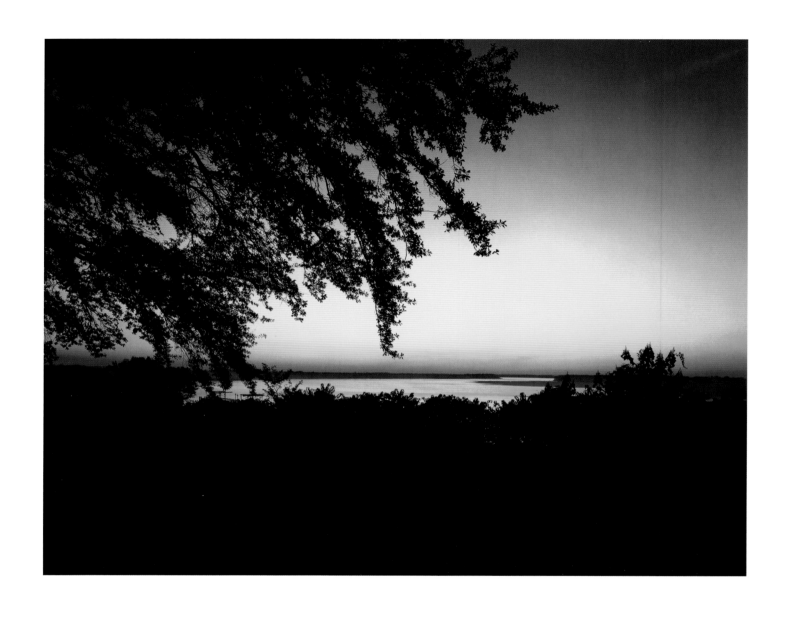

The Mississippi River at dusk, from a mound built in A.D. *400–700,*
Chickasaw Heritage Park near the Memphis-Arkansas Bridge, Memphis. (1991)

Larry E. McPherson

with an introduction by
Charles Reagan Wilson

Published by
The Center for American Places
Santa Fe, New Mexico
and Harrisonburg, Virginia

in association with the
University Press of Mississippi
Jackson

Memphis

© 2002 Center for American Places

Photographs © 2002 by Larry E. McPherson

All rights reserved

Published 2002. First edition

Printed in Iceland on acid-free paper

The Center for American Places, Inc.

P.O. Box 23225

Santa Fe, NM 87502, U.S.A.

www.americanplaces.org

Distributed by the University Press of Mississippi

3825 Ridgewood Road

Jackson, Mississippi 39211-6492

www.upress.state.ms.us

Book orders: 800-737-7788

Information: 601-432-6217

9 8 7 6 5 4 3 2 1

Library of Congress Cataloging-in-Publication Data
McPherson, Larry E.
 Memphis / Larry E. McPherson; with an introduction by
 Charles Reagan Wilson.—1st ed.
 p. cm.
 Includes bibliographical references.
 ISBN 1-930066-03-1 (alk. paper)
 1. Memphis region (Tenn.)—Pictorial works. 2. Memphis
region (Tenn.)—Description and travel. 3. Memphis region
(Tenn.)—Miscellanes. I. Title

F444.M543 M38 2002
976.8'19—dc21

2002019309

ISBN 1–930066–03–1

PUBLISHER'S NOTES:

This book was brought to publication in an edition of 3,500 hardcover copies with the generous support of the following individuals and organizations, for which the publisher is most grateful:

Shelby County Mayor Jim Rout

The University of Memphis Foundation

The College of Communication and Fine Arts of the University of Memphis

The Office of Research and Graduate School of the University of Memphis

Joy and Fred Rickey

As part of the *Gallery Books* program of the Center for American Places, the publication of this book accompanies an exhibition of photographs on Memphis and environs by Larry E. McPherson at the Lisa Kurts Gallery, in Memphis, Tennessee, on view from 26 April to 31 May 2002. The publisher is indebted to Lisa Kurts for her support of the book and Mr. McPherson's photographic work.

For information about the Center for American Places and the publication of *Memphis*, please see page 148.

For my mother

and father

Ethel and Gene

McPherson

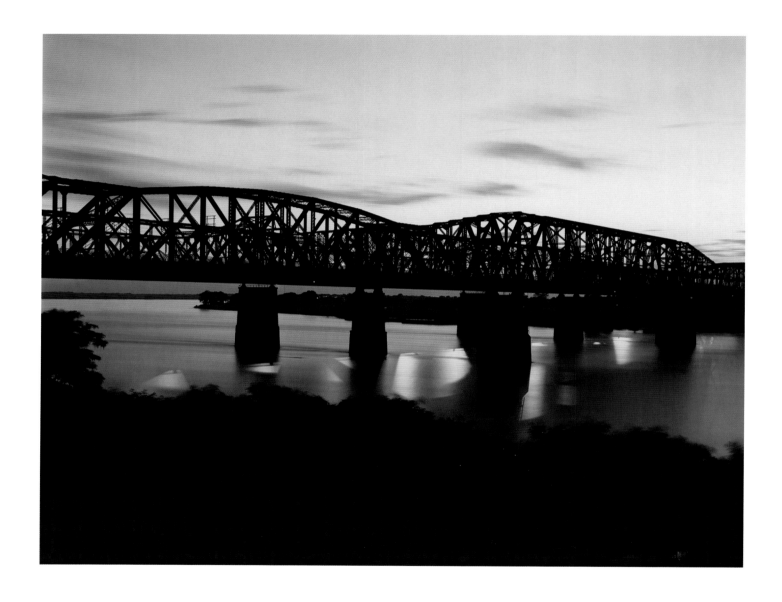

Three of the four bridges that span the Mississippi River at Memphis are seen here from the Church of the River grounds. The Frisco Bridge (1892), the first bridge built across the river south of St. Louis, is in the middle; the Harahan Bridge (1916) is the first in view; and the Memphis-Arkansas Bridge (1945–49), which carries Interstate 55, is on the far side. At this point on the Mississippi River the height of the water can vary more than fifty feet, and the width can vary from one-half to three miles. (1991)

Contents

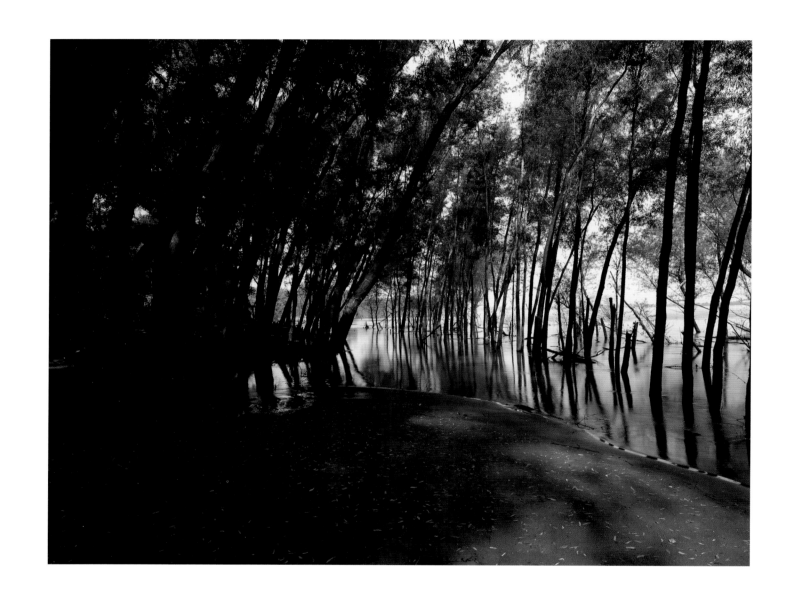

A willow grove along the eastern bank of the Mississippi River
south of Duvall Landing, Tipton County. (1998)

THE INSPIRATION FOR THIS PROJECT came from the French photographer Eugene Atget (1857–1927), whose legendary photographs of Paris were ultimately expressions of his love for his city. While photographing, I was guided by the injunction of contemporary American photographer Robert Adams (b. 1937) "to be hopeful if I can also be truthful" and to make pictures "that help keep intact an affection for life." And, like the well-known American photographer Walker Evans (1903–1975), I believe in the importance, while photographing, of being guided by intuition. As Evans said, "The real gift and value in a picture is really not a thought; it is a sensation that is based on feeling."

My plan was to start photographing at the Mississippi River and work my way through downtown, midtown, and the suburbs, and then head out into the countryside. I started photographing the Mississippi River along the downtown riverfront in 1991. From there I began working in the city, but I didn't feel attuned to it. So I moved fairly quickly to photographing in the countryside around Memphis. I was more comfortable photographing in the country and continued to concentrate my efforts there for several years.

In 1996, I showed that work to George F. Thompson, president of the Center for American Places, with the idea of making it into a book. He insisted that a book about the area had to include the city. So I started photographing the city again, particularly at its outer edges. I started with suburban development and corresponding road building. At the same time, I followed my natural affinities and photographed the natural areas along the Mississippi and Wolf rivers. In the spring of 1999 I became excited while photographing in a twenty-block area of downtown where I could feel the city's history. After that it was a matter of filling in the gaps (neighborhoods, roads, and key landmarks) to complete the book.

The process of photographing for *Memphis* has increased my knowledge of and love for the city. This book is my gift to the people of Memphis who gracefully embraced my photographing our community.

Preface

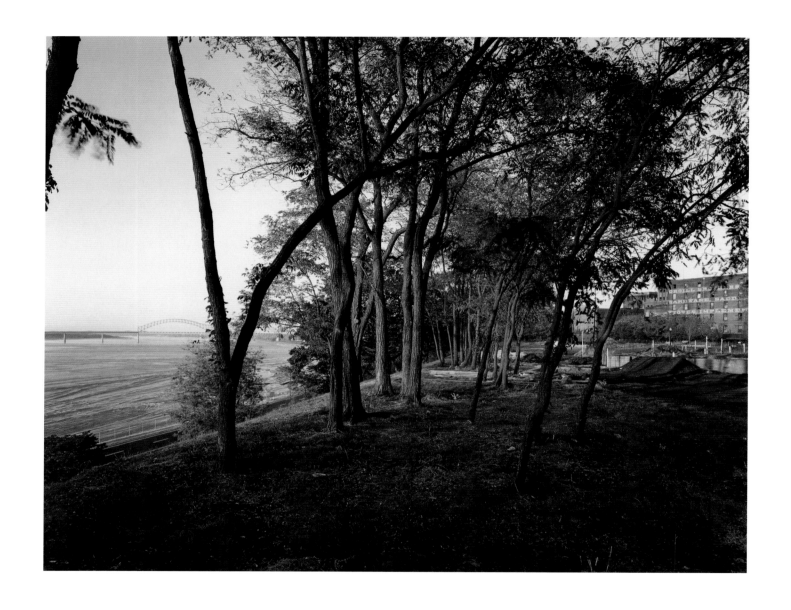

Home construction, in the right foreground of this view north from the bluff top, during the early development of South Bluffs. Orgill Brothers Hardware and the Tennessee Brewery can be seen in the right background, and on the left, next to the Mississippi River, is sand freshly pumped out of the river to enlarge Tom Lee Park. (1991)

MANY PEOPLE AND ORGANIZATIONS have helped make this book a reality. First, I want to thank the farmers, homeowners, company managers, security personnel, and others who graciously permitted me to make photographs. The gift of their friendliness, enthusiasm, and assistance is appreciated.

Thanks to Jason Waits for introducing me to many Tipton County farmers, and to Brenda and Hugh Waits for their hospitality and their interview. Thanks to Austin Tate for showing me around the Bluff #2 area and to Eddie Hunter for access to it. For permission and assistance I thank Minor Spencer and Elbert Browley of Boxtown; Tura Wolfe, property manager at the Shrine Building; Felecia Boyd in Mud Island publicity; James Sloan with Beers-Inman, supervisor of AutoZone Park construction; Tom Fillmore of Trammell Crow Company, Property Management of One Commerce Square; Sue Stovall and Jim Kilboy at 99 Tower Place Apartments, Ledic Management Group; Jason Jones of the Memphis Redbirds Media Relations; Joey Malinowski and Dan Bills of Peabody Security; Danny Tay-lor of Full Gospel Tabernacle; Miss Pope, Mr. Bryant, and Mr. Milstead at Barry Homes; Margretta Dobbs in marketing at Memphis Shelby County Public Library; Gary Hallmon at HBG Management; John Rone and Bill Short at Rhodes College; Bill Day at the Hunt-Phelan House; Lynn Doyle and John Joplin with Memphis in May; and Mari Askew and Patrick Foley who greatly aided my bluff-top efforts. I thank Pam Roberson of FedEx public relations and David Keeton at the FedEx World Technology Center for their assistance. I thank John Spiess, general manager of the Tournament Players Club at Southwind, for personally escorting me around the golf course.

I thank Kelly Hill and Bobby Davis of the Graceland Division of Elvis Presley Enterprises, Inc., for assistance in photographing Graceland Mansion. Elvis, Elvis Presley, and Graceland are registered trademarks of Elvis Presley Enterprises, Inc. All rights reserved.

I am also grateful for those who have taught me firsthand about the area. Larry Smith and Naomi Van Tol of the Wolf River Conservancy shared their knowledge about and enthusiasm for

the Wolf River. Charles McClain took me in his canoe into the Ghost River Section of the Wolf River and watched over me as I waded waist deep into the swamp to photograph. Larry Wilson took me to his "west forty" on Crowley's Ridge.

I thank Judith Johnson of Memphis Heritage, Inc. for her valuable historical perspective and for suggestions for writing the captions. I am indebted to Jim Johnson, Patricia LaPointe, and others in the history department of the Memphis and Shelby County Public Library for assisting my research for the captions. Jim Pogue and Brenda Beasley of the U.S. Army Corps of Engineers, Memphis District, greatly aided my research on the Mississippi River. Edwin Franks, curator of special collections at the University of Memphis Library, graciously checked the captions and bibliography for accuracy. Jim Cole, also at the University of Memphis Library, assisted me in preparing the bibliography on Memphis music and the list of recordings. Both the Shelby County and Tipton County Assessor's Offices supplied building dates. Robert Ruetting of the Shelby County Assessor's Office diligently researched some hard-to-get dates.

I thank Charles Wilson for his introduction and enthusiastic support of the project. I appreciate his taking the time from a very busy schedule to come to Memphis to see firsthand the terrain covered and to learn about my attitudes.

I thank my colleagues and students at the University of Memphis for their enthusiasm and support of this project. The insights and individual expertise of David Dye, David Evans, Stanley Hyland, Tom Medina, and Steve Ross greatly improved the quality of the captions and bibliography. I am especially grateful to Jed Jackson, chairman of the department of art, for

his support and to the university for a faculty development leave that gave me time at a critical point to work on the project.

I am deeply grateful to my good friends Steve Foster, Dick Blau, and Tom Bamberger for generously giving their time to view the photographs and give useful feedback at every stage of the project. I thank Stan Franklin for his good counsel and enthusiasm throughout the project; Jack and Nancy Hurley for their advice and encouragement; and John Reed for going over many drafts of my writing and for his encouragement.

I thank Tom Bamberger, Frank Gohlke, and Greg Conniff for putting me in touch with George F. Thompson at the Center for American Places. I am very grateful to George for his vision for the project and for his skill in picture selection, sequencing, and the publication process. Also at the Center, I thank Randall B. Jones for his intelligent and patient assistance to me throughout the publication process. I thank Seetha Srinivasan, director, University Press of Mississippi, for her personal interest in and valuable input to this project; Anne Stascavage, also of the University Press of Mississippi, for her excellent copyediting; and David Skolkin, of Santa Fe, for his elegant book design.

This book has been brought to publication with the generous assistance of Shelby County Mayor Jim Rout; the University of Memphis Foundation; the College of Communication and Fine Arts and the Office of Research and the Graduate School of the University of Memphis; and Joy and Fred Rickey. I am deeply grateful for this support. I thank Lisa Kurts of Lisa Kurts Gallery; Tom Jones in the Shelby County mayor's office; and Linda Brinkley, Ralph Faudree, Richard Ranta, and Kevin Roper at the University of Memphis for their assistance in the fundraising.

Memphis

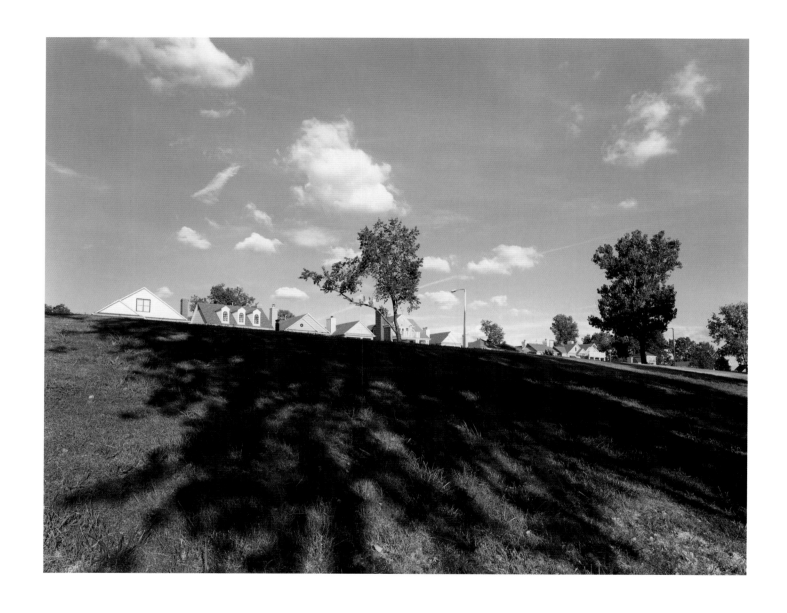

New homes in the Island Crest neighborhood, seen here from the Mississippi River bank, are part of the upscale development on Mud Island that began in the 1990s. This has played a role in the revitalization of the downtown area that, from 1990 to 2000, doubled its population. In a March 1999 article in The New Democrat, *Richard Moe and Carter Wilke wrote that "a downtown declared dead after the death of Martin Luther King, Jr., in 1968 is returning to life at an encouraging pace. Historic downtown and urban waterfronts have a future as appealing alternatives to sprawl." (1998)*

MEMPHIS HAS HAD MANY MONIKERS that have come out of its location and environment. Mark Twain called it the Good Samaritan of the Mississippi. Shields McIlwaine, writing in the mid-twentieth century, claimed that people in the countryside around the city looked forward to going to the Big Shelby (referring to the county in which it resides). Likely as not, one now hears it called the Crossroads of the Mid-South.

The recurrent name that resonates, though, is the Bluff City. The earliest settlers of the environs around Memphis appear to have been prehistoric cave dwellers, living in rock shelters along the Wolf River near the Bluffs. At four spots on the western edge of Tennessee, sharp cliffs rise high above the river. Inhabitants have called these the Chickasaw Bluffs (pages 126 and 127) because the Chickasaw Indians claimed as their turf the lands of western Tennessee and northern Mississippi. Memphis arose on the lowest, or fourth, Chickasaw Bluff, whose flat plain stretches miles to the east, between the Wolf River on the north and Nonconnah Creek to the south.

The Bluff has given a sense of place to the people of Memphis from earliest recorded times, the scene of remembered events. Hernando de Soto "discovered" the Mississippi River for Spain while standing on the Bluff—as I was taught in school years ago—or at least was the first to see it through European eyes. De Soto called it the River of the Holy Ghost, understanding that a river can indeed have a spiritual dimension. He intruded into a land of indigenous peoples who had once built giant mounds as ceremonial and sacred centers. In Chickasaw Heritage Park (originally called De Soto Park), in the modern city's downtown beside the river, one can still see such mounds (page ii). A granite boulder nearby pays homage to De Soto for opening this land to further development.

Later, French sojourners came, and then the Spanish again and the English, and finally the Americans. Land was at the center of a shady real estate deal that led to the formal appearance of Memphis. North Carolina made a land grant of west Tennessee territory, which it did not own, to three Americans (including Andrew Jackson), who effectively asserted their claim

An Introduction to Memphis
Charles Reagan Wilson

to what would become Memphis after an 1818 treaty with the Chickasaws. Tennessee incorporated Memphis in 1826, printers established a newspaper, and stores, repair shops, sawmills, and cotton warehouses soon followed. The Scots-Irish, Scottish highlanders, Irish, and Germans became key early settlers in this working-class community.

Memphis was high above the Mississippi River, but water fed its early growth and emerging prosperity. Barges and flatboats began plying the river, connecting Memphis with New Orleans to the south and the Ohio River to the north. Steamboats were, ironically, stable points on the horizon for early Memphians, transporting people and goods but also evoking the sights and sounds of place for generations of its people. Memphis grew in the 1850s from 6,427 people to 33,000, and became one of the young nation's busiest ports. The river culture would long make Memphis one of the roughest American places as well. Mark Twain described the infamous "Murel's Gang," pirates who cruised the Mississippi River before the Civil War, hiding out on its islands, "a colossal combination of robbers, horse-thieves, negro-stealers, and counterfeiters." Even aside from such outright criminals, the river brought hard-bitten, hard-working men and women to Memphis's docks looking for the pleasures of a wide-open port.

The Civil War ended a Memphis boom that grew out of the growing cotton market of the 1850s. The city was a western frontier town but even more an anchor of the southern cotton kingdom. It became a Confederate military center when the war began, but on June 6, 1862, the river that was the source of its prosperity now became the source of its military defeat. Union naval forces captured Memphis after a brief, ninety-minute bat-

tle, which the city's population watched from the bluff overlooking the river. Cavalry raider Nathan Bedford Forrest later carried off a spectacular Confederate raid in August of 1864, in which his horsemen even rode into the Gayoso Hotel looking for Union officers. But mostly the city settled into a new wartime routine of tolerating Yankee occupation that left plenty of room for trading with both combatants.

The war left its mark on the landscape. In 1908 Memphis unveiled Confederate Park. Located on the waterfront slope up to Front Street, this memorial to the Civil War battle of Memphis is home to a statue of Jefferson Davis, a plaque containing the Ten Commandments, and (now) artillery from World War II. Forrest Park, opened in 1915, honors the heralded Confederate raider, Nathan Bedford Forrest, who was also a slave trader and founder of the Reconstruction-era Ku Klux Klan. Forrest was the hero of the wartime raid against Union forces and a post-war Memphis resident who farmed a plantation on President's Island, dying there in the 1870s from a disease contracted from drinking polluted water. Forrest and his wife are buried in the park, beneath a statue of the general that portrays him as a romantic hero, reflecting the early twentieth-century Lost Cause nostalgia.

The Civil War left its mark on Memphis, but nothing to compare with the effects of yellow fever. Epidemics hit Memphis in 1867 and 1873, but the outbreak in 1878 was the devastating plague. More than 25,000 fled within the first few weeks and 5,000 more took refuge in nearby camps. Surrounding towns quarantined Memphis. Bayou Gayoso had become an open sewer and breeding ground for mosquitoes by the 1870s, and here the epidemic began—polluted water threatening the very

life of the city. More than 17,000 people caught yellow fever, and 5,150 died. The result was a 20 percent decline of the city's population by 1880 and the loss of Memphis's operating charter to the state because of its inability to provide minimal government services.

Clean water enabled Memphis to be reborn. Engineers built a new citywide sewer system, based on a model of continuous water flow, a method which became famous as the Memphis System. Mark Twain visited in the late nineteenth century and called Memphis "a beautiful city, nobly situated on a commanding bluff overlooking the river," but he noted that "admiration must be reserved for the town's sewerage system, which is called perfect." A key discovery came in 1887, when Memphis found it sits on top of millions of gallons of pure artesian well water, which soon replaced the Wolf River as the city's principal source of drinking water. Memphis now began adding the stable objects of a growing urban area. The first electric streetcars appeared in 1881, and Main Street saw the city's first streetlights the following year. The first public library opened in 1893, an imposing Romanesque structure that reflected increased awareness of the need to nurture culture, and the first skyscraper—the Continental Bank Building (now the D. T. Porter Building) (page 30)—rose up in 1895, a sure sign of modernity on the landscape. Perhaps nothing was more important, though, at the turn of the twentieth century than the building of the first railroad bridge across the Mississippi River in 1892. The Frisco Bridge (page vi) was the only bridge over the river south of St. Louis, so that all southwestbound rail traffic from the Atlantic seaboard and the Deep South now funneled through Memphis, and enormous trade opened with the Southwest. The Harahan Bridge opened

in 1909 and was rebuilt in 1915–16 to serve those crossing the river. By the 1930s, ten railroad lines served Memphis, as did four steamship lines, five freight forwarders, and eleven general warehouses to service the huge commercial business activity stemming from Memphis's transportation improvements.

Common land took on a new value as Memphis grew in the early twentieth century, and parks became new symbols of place for generations of Memphis residents. The city established the Board of Park Commissioners in 1900, and it soon developed Riverside Park (now called Martin Luther King, Jr., Riverside Park), a naturally wooded 427 acres, bordering the Mississippi River for a mile and a half along grassy bluffs, with picnic grounds, a golf course, a lake, and pavilions where people hear the music so important to the community. The Park Commissioners acquired 335 acres of land in 1901, and construction began in 1905 on Overton Park (page 80) at the then-eastward edge of town. Park designers set aside 100 acres of virgin forest, as well as driving areas, bridle paths, landscaped open spaces, camp and picnic grounds, an open air drama arena, sculpture, a pond, and a zoo.

The Commission linked its two new parks with the Parkway road system, ringing the city with roads (pages 79, 82, and 83). By the second decade of the century, automobiles had begun their transformation of the city. There were 3,000 cars by 1910, a number that doubled within three years. The automobile enabled Memphis to annex surrounding settlements to the east and new subdivisions began to appear. In 1929 alone, the city incorporated more than twenty square miles of suburbs.

Land itself remained central for Memphians trying to understand their distinctive place. "Memphis, unlike other Tennessee

cities, remains to this day a 'land-oriented' place," writes the late novelist Peter Taylor. Speaking of those atop the southern social hierarchy, he writes that "everybody there who is anybody is apt still to own some land," likely in Arkansas, West Tennessee, or the Mississippi Delta. The deep black bottomlands surrounding Memphis are the source of prosperity for the elite and were long the hearth of the cotton economy that sustained Memphis's working class citizens as well. If cotton was king anywhere, Memphis was the capital of his empire. Men made fortunes from the rich alluvial soil and then moved to Memphis, to live in appropriate residencies befitting their status. They, or their sons, became cotton factors selling white gold to the world.

Cotton Row was one landscape expression of the importance of the plant to Memphis. This was the name of the cotton mercantile buildings along Front Street (pages 22, 28, and 29), in the city's central business district. This location enabled cotton merchants to be near the Mississippi River, where stevedores moved cotton for transport from the South to national and international markets. Bales of cotton moved easily in and out of the spacious ground floors in these unadorned, simple structures whose clean lines and simplicity masked the power of the business they housed.

Ceremonial rituals become the seasonal expressions of a sense of place, and Memphis long had its Cotton Carnival that celebrated, with revelry, the stability of countless heavy bales of cotton passing through the Port of Memphis out to world markets. It began in 1931 as a revival of the Mardi Gras celebrations of the late nineteenth century in Memphis. Pageants presented the city's story as the tale of cotton. Beale Street was home to an African American part of the celebration—called "The Negro Sings"—with "coronation" and "jubilee" parades, oratorical con-

tests, track meets, a lawn tea, a Friday evening ball, and much singing throughout. It drew locals and also was a fine excuse for visitors to see the city.

For country folk in the nearby hinterlands, Memphis was indeed the big city. Innumerable visitors from the countryside rode their first elevator or boarded their first streetcar in Memphis. Both Mayor E. H. Crump and African American social reformer Ida Wells-Barnett came from Holly Springs, Mississippi, to make their mark in Memphis, two of generations of migrants to this urban magnet. Few other southern cities could have derived their livelihood and character so thoroughly for so long from such a large satellite area of farm lands and small communities.

Much of Memphis culture derived from its rural networks as well. Consider blues music, one of the creative expressions for which Memphis is known worldwide. The convergence of African American musical traditions from western Tennessee and northern Mississippi made the Memphis blues that emerged from country dance tunes, urban folk sounds, and country blues.

Beale Street (pages 42–44) was the wellspring of black Memphis sounds and as clear an embodiment of an urban sense of place as existed anywhere in the United States. It was tied to the Mississippi River, as the street began at the riverside dock where roustabouts heaved their heavy loads of commerce. Theaters, pool halls, barber and beauty shops, bars, houses of ill repute, department stores, and restaurants lined the streets. Merchants in an open marketplace hawked everything from vegetables, pigs feet, and live chickens to clothing, jewelry, and graveyard dust (needed for hoodoo spells). The WPA guidebook to Tennessee evoked the sensory feel of this Memphis place in the 1930s,

describing the air as "thick with the smell of fried fish, black mud from the levees and plantations, and whisky trucked in from the moonshine stills of swamps and hills." The pianos in crowded juke joints let loose "the slow, 'hesitation' beat of the blues, or the furious stomp of swing music."

Handy Park (page 33) became the most abiding landscape expression of permanence of this Memphis place. In 1931, former Mayor E. H. "Boss" Crump dedicated this park to W. C. Handy, the "father of the blues," who was the most prominent musician of the city and surrounding countryside in the early twentieth century. Ten thousand spectators gathered for the dedication of the park, as fraternal societies, marching clubs, singing groups, and bands marched down Beale Street, singing "Beale Street Blues," to the new park, which quickly became the center of street life. In 1960 the city dedicated a statue to Handy in the park, which has remained an anchor for the new Beale Street, commercialized home to tourists but also still the center for a lively Memphis music scene.

Around the corner from Beale Street is another Memphis landmark that has been a stable object of place—the Peabody Hotel (page 31). Opening in 1925, the hotel became especially famous for its lobby, designed by Chicago architect Walter Ahlschlager to evoke a Spanish hunting lodge. A fountain in the lobby added both a certain panache and, in 1932, the famous ducks splashing in the fountain, a tradition that began when the hotel manager came back from a hunting trip with live ducks he put in the fountain. The Peabody lobby is the ceremonial center of Memphis, drawing together businessmen for deals, politicians for gladhanding, out-of-towners for a taste of big-city elegance, and generations of school graduates for banquets and parties. A famous saying has it that the Mississippi Delta begins in the lobby of the Peabody Hotel, accurately reflecting its importance as a social center of Delta life, tying it to the city.

Like much of the Mid-South that surrounds it, Memphis often has embodied a preference for traditional ways. The landscape expressed this preference through its conservative architecture, especially seen in preferences for a classical residential style that tied Memphis to the Deep South. The few great houses built before the Civil War were classical in design, with stress on symmetry, clear shapes, and the defining white columns in the front of houses. This is not to say that Memphis did not have its wonderfully quirky Victorian houses (such as those few surviving in the Victorian district), English Tudor residences, Italian-Mediterranean homes, and even Art Deco designs by the 1930s.

Relentlessly, architects returned to classical designs. In the Depression of the 1930s, the Memphis *Commercial Appeal* and its radio station WMC (which it owned from 1923 to 1993) sponsored a model house to encourage people to borrow money to buy homes. The house was modest, but it had the defining classical southern revival columns designed to appeal to a populace steeped in it, at whatever income level. The campus of the University of Memphis (formerly Memphis State University) was another good example of the persistence of this style that drew together the older South and the new. Some early campus buildings were classical revival, but then in the 1960s architects made a conscious effort to emulate the look of the greatest classical designed campus, the University of Virginia, and the Memphis campus augmented its traditional southern look.

Modernity eventually asserted itself, to be sure, a by-product of Memphis expansion. East Memphis became a major residential area in the 1920s in response to population pressures, as neighborhoods grew up supplementing the Central Gardens

(pages 68 and 76) and Evergreen (pages 66 and 69) residential areas. New subdivisions such as Chickasaw Gardens, Red Acres, and Hedgemoor (page 73) appeared. After World War II, even more extensive expansion took place, and more modern building styles began to appear. Poplar Plaza Shopping Center was the first major commercial development outside of the downtown area, and it was famously modern. By the 1980s, new subdivisions such as River Oaks reflected the region's contemporary prosperity that could produce truly upscale residential developments.

For Memphis's working class, modernity has often been a blessing, as refugees from the older, dead-end sharecropping economy found sanctuary in the city. Memphis became well known for its two public housing projects of the Depression era—Lauderdale Courts for whites and Dixie Homes for blacks. Both were slum clearance projects that created livable environments that surely improved on the housing that many residents had known. Lauderdale Courts (pages 34 and 35) used a modified Georgian Colonial style—again connecting residents to an older South—in its design of the four hundred apartment units in the 1930s. Elvis Presley's family would qualify for residence in the late 1940s, a sure advance over their difficulties that drove them out of Tupelo, Mississippi. Constructed at the same time as Lauderdale Courts and by the same architect, J. Frazer Smith, Dixie Homes were of a fashionably modern design and provided a constructive response to the obvious need for improved public housing for African Americans as well as whites in the segregated city.

Post-1960s Memphis expansion has reflected the growing racial divide in the South, with white flight taking place after the tragic assassination of Martin Luther King, Jr., in Memphis in 1968 and the resulting urban conflagration. The Memphis Housing Authority seized this moment to destroy the heart of the traditional black community in Memphis—Beale Street. This urban renewal tore down entire neighborhoods without providing replacement homes. Houses and commercial buildings from the late nineteenth-century downtown area were literally lost to collective consciousness by this calculated destruction, a good example of how a sense of place can be threatened by public policy that little values the landscapes of a diverse past.

The new locus of Memphis is surely far from its point of genesis. In 1989, the *Commercial Appeal* wrote that a new hotel, the Hyatt Regency (now Adam's Mark) (page 90), at the intersection of Poplar Avenue and Interstate 240, once at the eastern edge of the city, was now "the maypole around which Memphis will revolve." The city that began as a river city has moved far away from the water. Germantown, in east Memphis, and the suburbs of northeast Memphis reflect the spread of people over land that once produced cotton and now supports residences for people who have little tie to that older economy.

Arguably, the air has replaced the river as the defining place of contemporary Memphis. The Memphis International Airport, built in 1959–63 with periodic additions, brings thousands of travelers, including Memphians, through the city each day, reflecting still Memphis's enduring significance as a transportation crossroads. Federal Express, headquartered in Memphis (pages 94 and 95), is an air-delivery business founded on the awareness of Memphis's value as a central American location. Its founder, Fred Smith, shows how past and present connect here. His grandfather was a steamboat captain working the Mississippi and Ohio rivers, and Smith's father also made his living from transportation—he founded and chaired Dixie Greyhound Bus Lines, one of the largest bus lines in the South. Young Fred

Smith was born in Marks, Mississippi, in the northern Mississippi Delta, and made his fortune in Memphis, seeing that the skies could be a part of the Memphis place as well as the river and roads his father and grandfather had understood.

Travel is indeed important to modern Memphis, the basis of a tourism industry economically vital now to the city. The Hernando de Soto Bridge (page 15), which opened in 1973, provides easy access to Memphis for drivers going east and west on Interstate 40, and the city is a regional and national conference center. Symbolically, the Holiday Inn motel chain began in Memphis, a place that understands movement—and the need to rest from it. Attractions such as Libertyland and the Liberty Bowl highlight the importance of recreation to modern Memphis. Graceland (page 77), Elvis Presley's home, is a leading Memphis tourist destination, and its story is a Memphis legend. Presley grew up in Memphis and chose to continue living here until his death in 1977. The house is a classical design on the outside, but has a relentlessly modern interior, reflecting the styles of the 1960s—that combination being itself an appropriate icon for Memphis.

The downtown is not to be forgotten in understanding contemporary Memphis. It is being revitalized, and one catches here glimpses of the spirit of Memphis, past and present. The mammoth Pyramid (pages 60–62) thrusts up from the landscape, a hard-to-miss marker from the perspective of both the Mississippi River, which runs north-south by it, and Interstate 40, which runs east-west by it. The Pyramid symbolically ties Memphis to its sister city on the Nile, but the visitors who come to see its college basketball games, trade shows, or cultural exhibitions embody contemporary Memphis's investment in recreation and entertainment as a communal expression of the modern sense of place.

Similarly, Mud Island (pages 2 and 15) has become the way most Memphians and visitors relate still to the Mississippi River. This peninsula extending down the Memphis harbor was built up by the deposit of mud and gravel against the stern of the Aphrodite, a gunboat used in the Spanish-American War, which anchored for over half a year in 1910 because of low water in the Mississippi. When it departed, a small sandbar had formed and continued to rise through deposits from the river in future years. In the 1970s, the city made Mud Island into a River Walk and River Museum, including a lengthy walk-through model of the Mississippi River (pages 16 and 17) and splendid views of it.

Mud Island, the River Walk, and nearby Tom Lee Park (wedged between Riverside Drive and the river) all figure prominently in "Memphis in May" (page 58), the celebration that has replaced the outdated Cotton Carnival. The focus now is on music, food, and Memphis's global ties, as the festival long has honored a different national culture each year. This Memphis remains southern, with its renowned barbecue cookoff, extensive musical performances, and festival life on the Mississippi River particularly resonant with Memphis's past.

"I'd rather be here than any place I know," W. C. Handy once sang about Memphis, and his use of the term "place" was exactly the point. Much later, young Elvis Presley, coming home from service overseas in the U.S. Army, answered a reporter's question about what he had missed about Memphis by saying "everything." A sense of place is not about one quality, nor one unique experience, nor one distinctive landmark, but the accumulated life of a place, seen through the natural environment, the sensory experiences, the legends, tales, and rituals that a people living in a space develop.

Memphis

and Environs

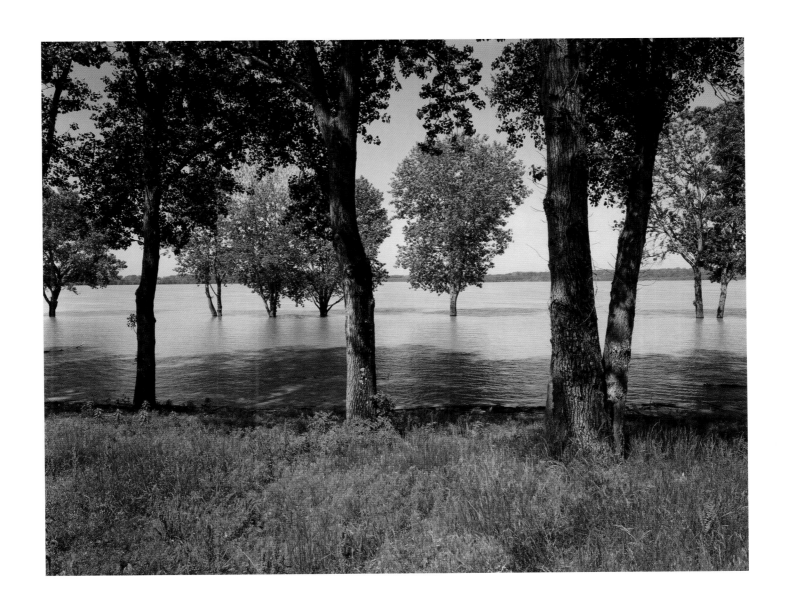

In this view from Mud Island near Island Drive and Auction Avenue, the Mississippi rises during a spring
highwater stage. According to Dave Bennett, Shelby County Engineer, the approximate volume of the Pyramid
(pages 60–62) is 198 million gallons. With an average water flow rate of 6 million gallons per second passing Memphis,
it would take the Mississippi thirty-three seconds to fill the Pyramid with water. As a comparison,
the average water usage of Memphis and Shelby County in 1998 was 150 million gallons per day,
an amount that would only partially fill the Pyramid. (1998)

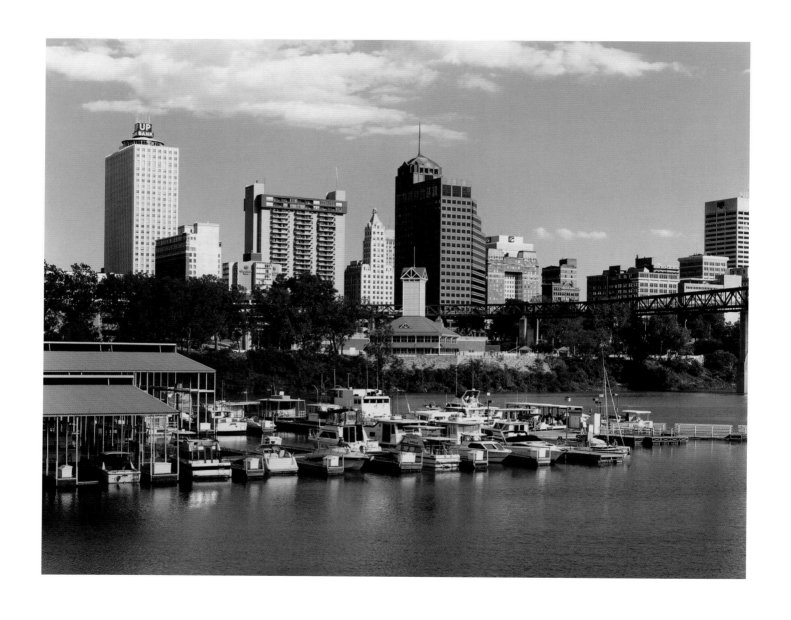

The high-rises of downtown Memphis overlook the Wolf River Lagoon and Memphis Yacht Club marina in this view from Mud Island. (1999)

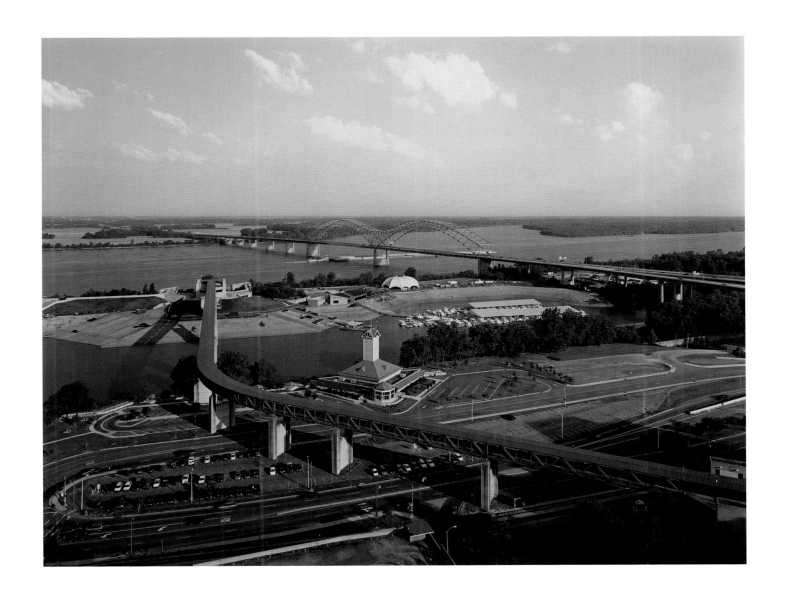

In the foreground of this westward view from 99 Tower Place Apartments, the monorail to Mud Island extends across Riverside Drive and parking lots. Beyond the parking lots are the Wolf River Lagoon, Mud Island Park, and the Hernando De Soto Bridge, constructed in 1973 to carry Interstate 40 across the Mississippi River to Arkansas. (1999)

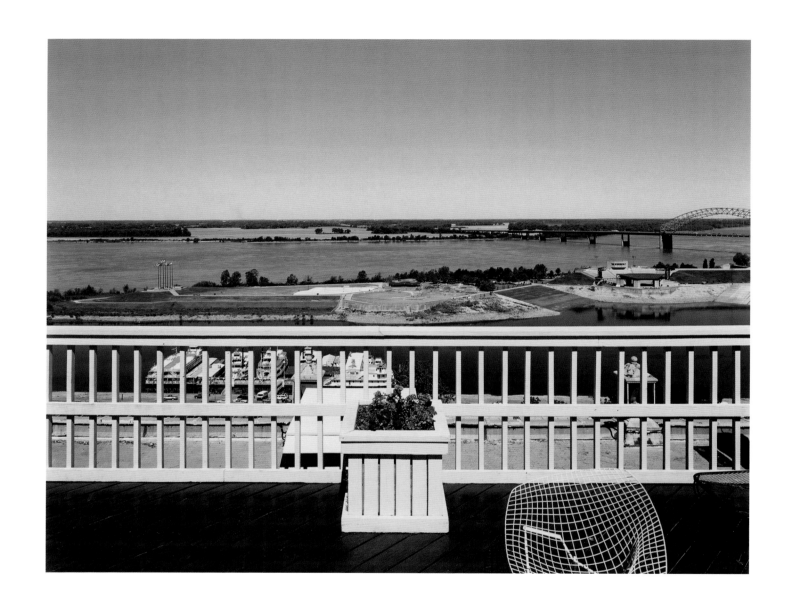

The Shrine Building on Monroe Avenue at Front Street, built in 1923 for the Al Chymia Shriners, was renovated in 1976 for apartments. From the roof, a spectator can see boats used for sightseeing cruises docked in the Wolf River Lagoon west of the apartments. In the center of the picture, at the end of the Mud Island Park River Walk, is a light blue pool of water that represents the Gulf of Mexico. Beyond that is the Mississippi River and Arkansas. (1999)

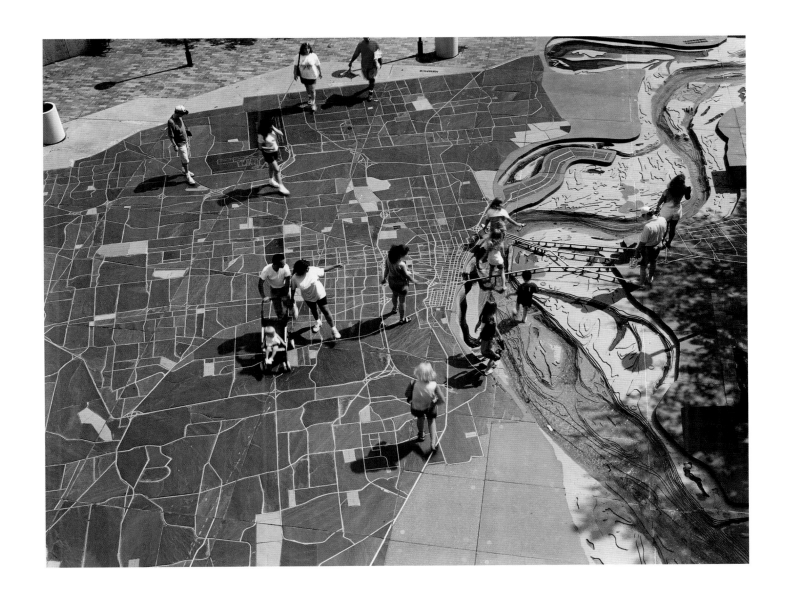

Visitors explore the Memphis section of the Mud Island Park River Walk, a flowing, five-block long scale-model of the Lower Mississippi River. "The people cannot conquer the river; it cannot shake them from its bank," wrote Juanita Brooks in a 1941 article for Harper's Magazine. *"It is like an endless war wherein first one side and then the other is victorious." (1999)*

17

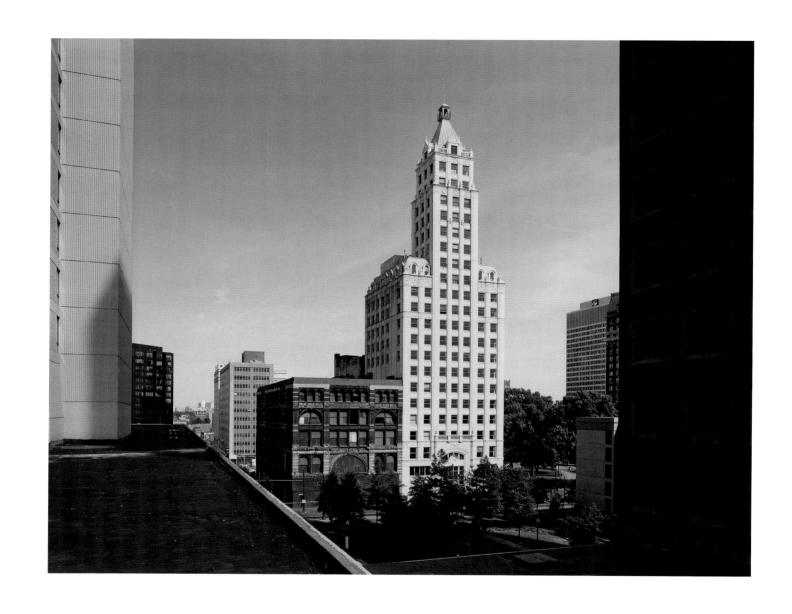

*The tall, white Lincoln-American Tower (originally Columbian Mutual Tower, 1924) at 60 North Main
is a smaller version of the Woolworth Building (1912) in New York City. In this view east from
99 Tower Place Apartments, the shorter building to the left at 72 North Main is the B.
Lowenstein and Brothers Building (1882). (1999)*

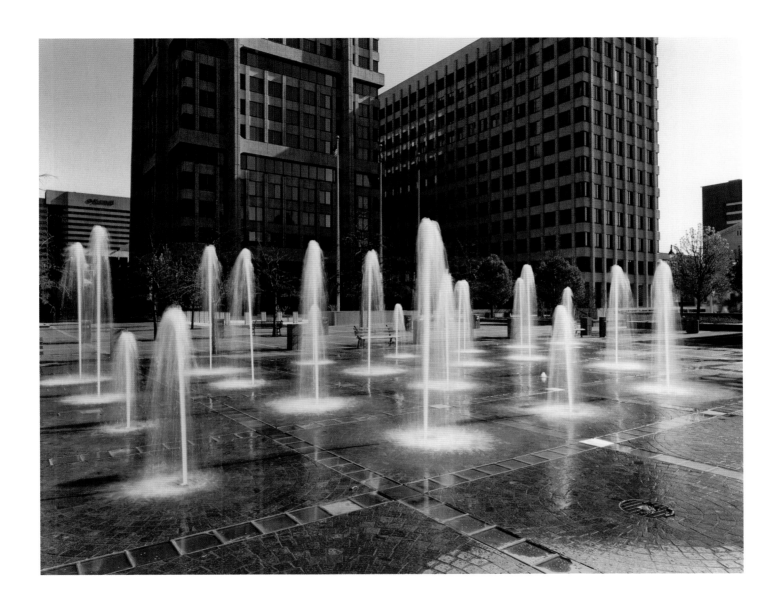

In the early 1990s, the Mid-America Mall, a section of North Main Street already closed to vehicular traffic, was redesigned to accommodate the trolley. Greg Hnedak designed the multiple jet Civic Center Plaza Fountain, which is integrated into the walking surface of the mall, thereby creating an interactive environment for visitors. In this northeast view from North Main between Adams and Poplar avenues, the Donnelley J. Hill State Office Building (1965) is on the left; the Shelby County Administration Building (1969) is on the right. (1999)

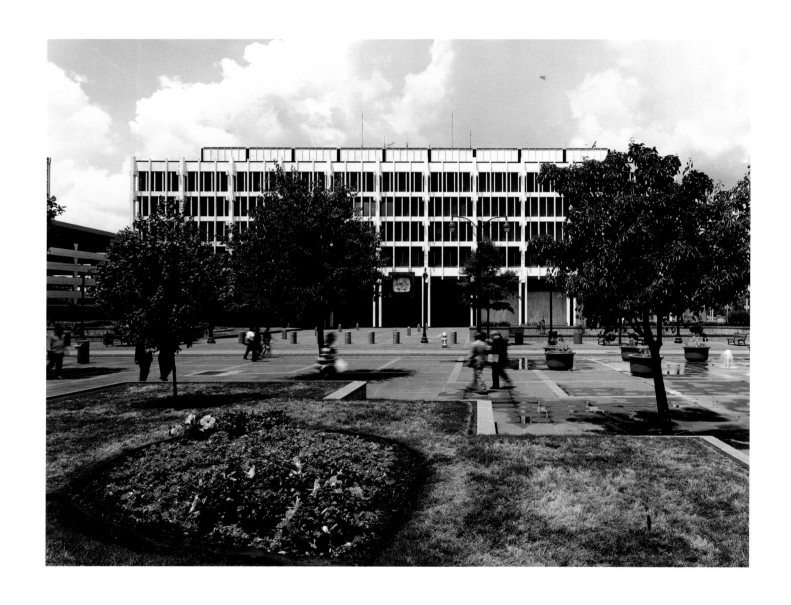

Memphis City Hall (1966), 125 North Main Street, seen here from across the Civic Center Plaza, was the destination of the marches during the 1968 sanitation workers' strike. (2001)

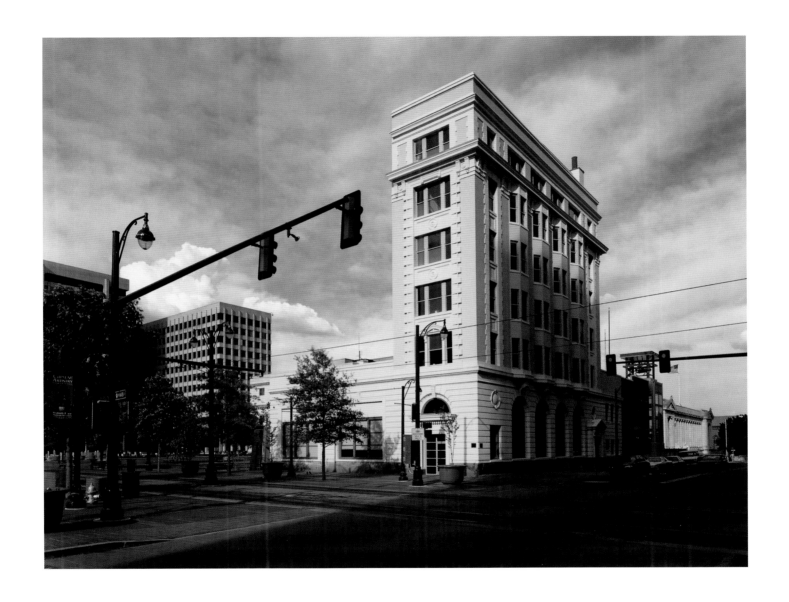

The E. H. Crump Building (1901) sits on the corner of Adams Avenue and Main Street. Originally the North Memphis Savings Bank, in 1921 the building became the insurance company office and command center for E. H. Crump, mayor of Memphis from 1909 to 1916 and Memphis political "boss" until his death in 1954. The building was renovated in 1997 and is now used by the Memphis Center City Commission. (1999)

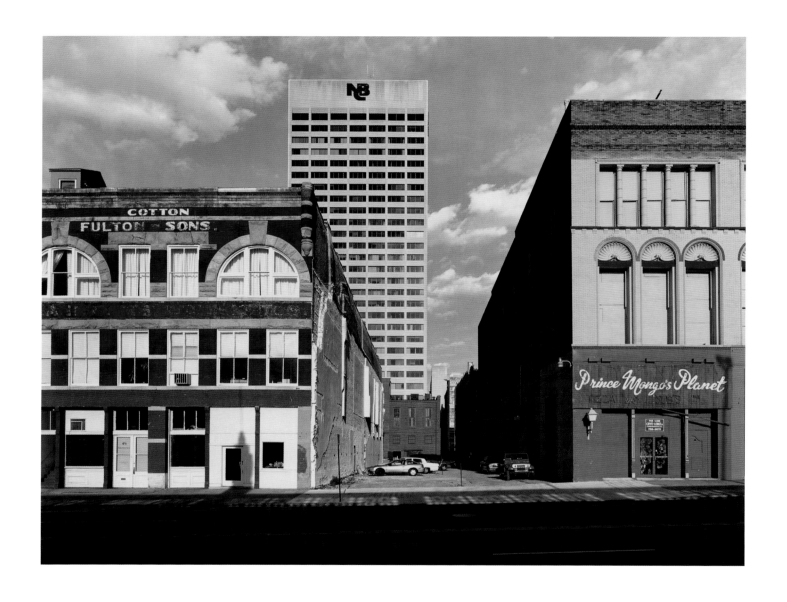

*The structures at 48 South Front (c. 1899) on the left and 60 South Front Street (1875, facade c. 1910)
on the right were relatively fancy buildings for Cotton Row. In the background the National Bank
of Commerce Tower (1968–70) is at the corner of Main and Monroe. (1999)*

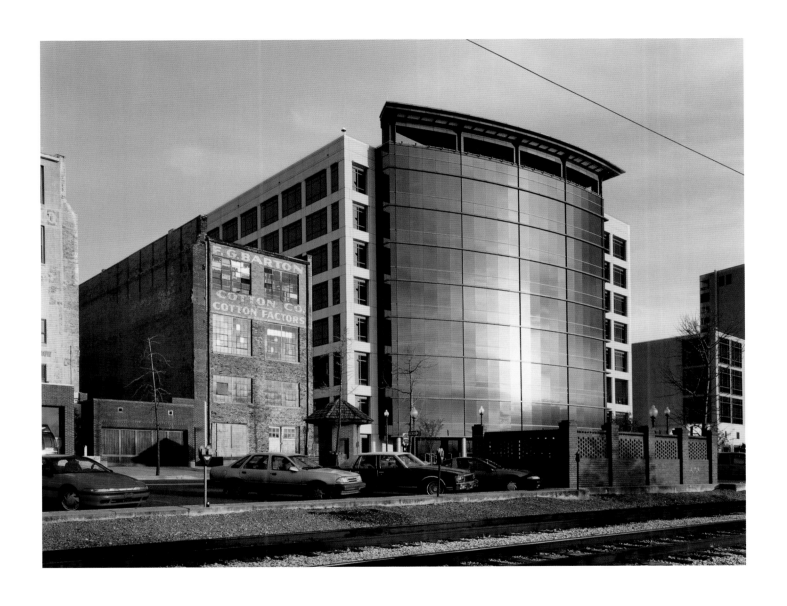

The AutoZone Building (1996), seen here from the Wagner Place side, faces west toward the Mississippi River. (1999)

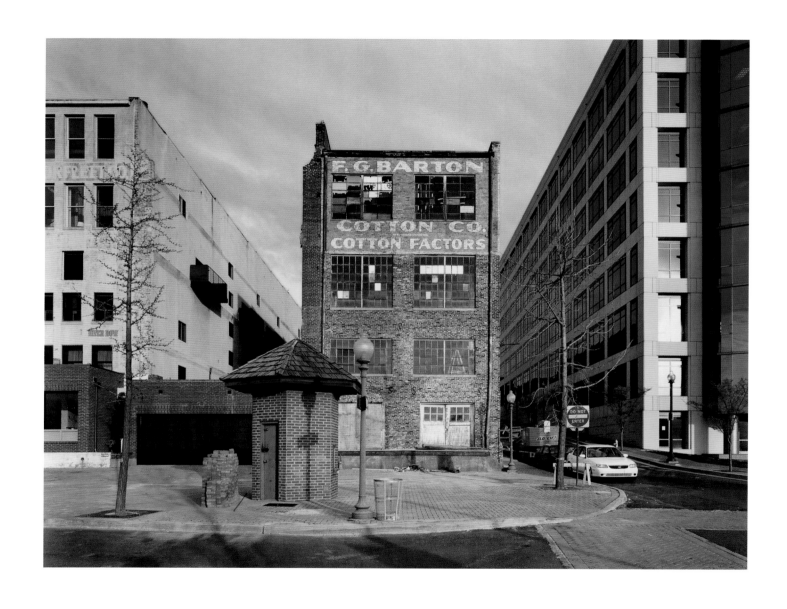

*Located next to the AutoZone Building, the F. G. Barton Cotton Company Building (1863),
seen from the Wagner Place side, faces the Mississippi River. (1999)*

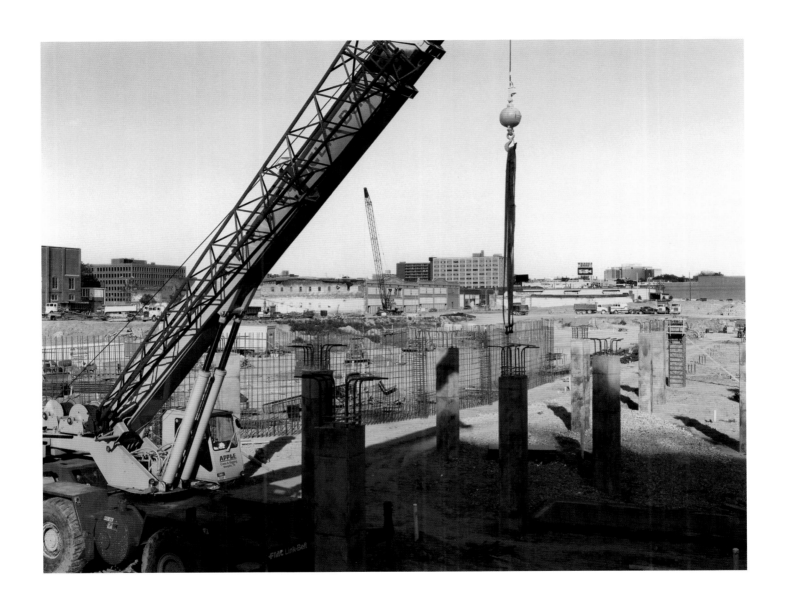

Foundation work for the new AutoZone Baseball Park, at the corner of Union and Third. (1999)

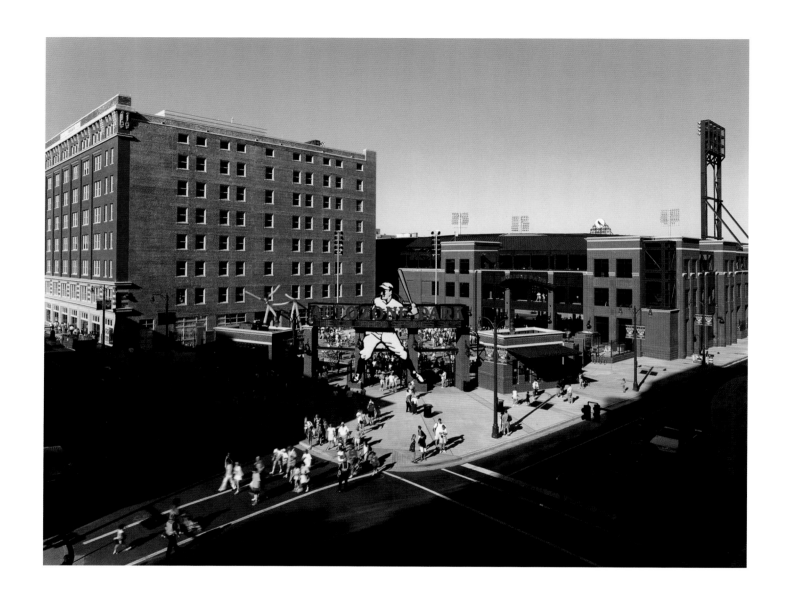

The entrance to the newly completed $80.5 million, 14,000-seat AutoZone Park at Union Avenue
and Third Street. The taller building on the left, the historic William R. Moore building (1913),
is being converted to the Toyota Center. (2000)

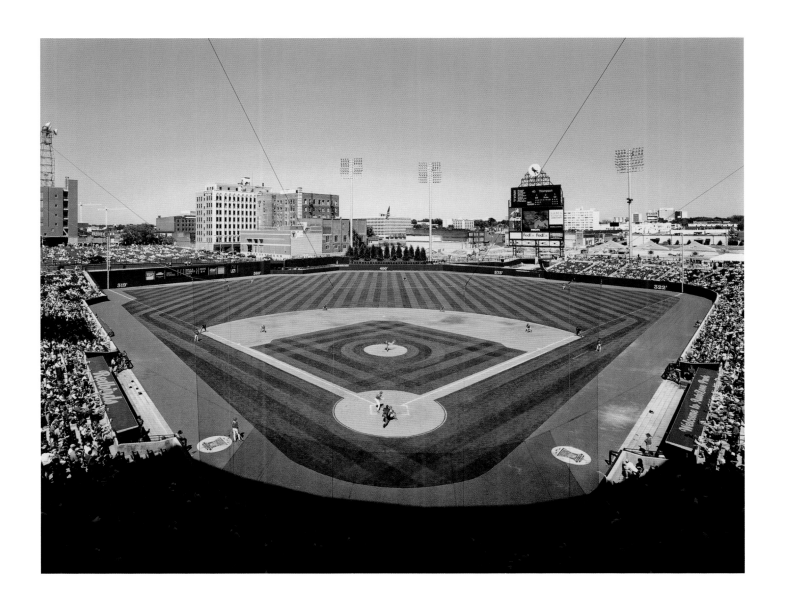

In this Sunday afternoon game of the Inaugural Season 2000 at AutoZone Park, the Memphis Redbirds
play the Albuquerque Dukes. It was the top of the fourth inning with the Dukes at bat.
The Redbirds won 6 to 3. (2000)

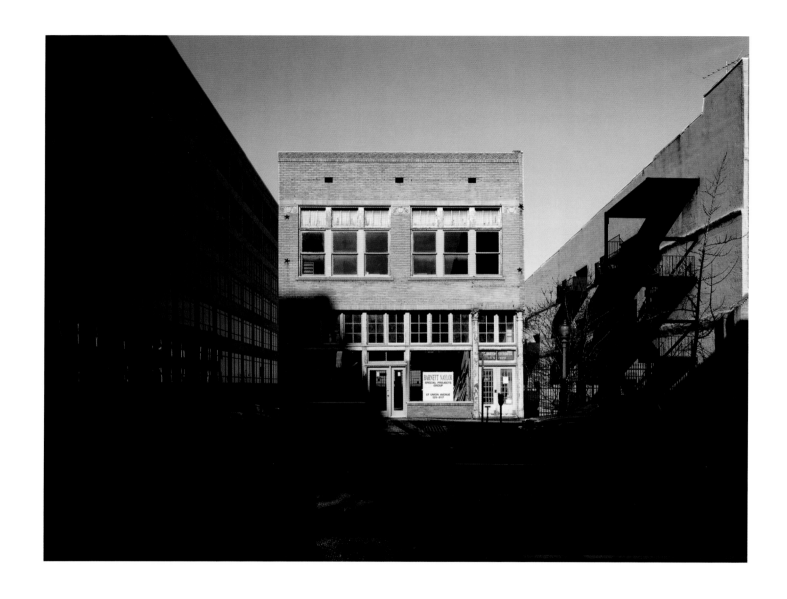

Cotton Row—Front Street between Jefferson Avenue and Beale Street—was the center of the cotton business. Cotton merchants had to be near the river on which the cotton was shipped in and out of town. This building at 115 South Front Street was initially a three-story built in 1863. In 1935, the F. G. Barton Cotton Company, which had been founded in 1902, moved into it. The company removed the third floor and put in skylights, enabling the workers to use the second floor for cotton classing. In 1999, the company moved to the Cotton Exchange. (1999)

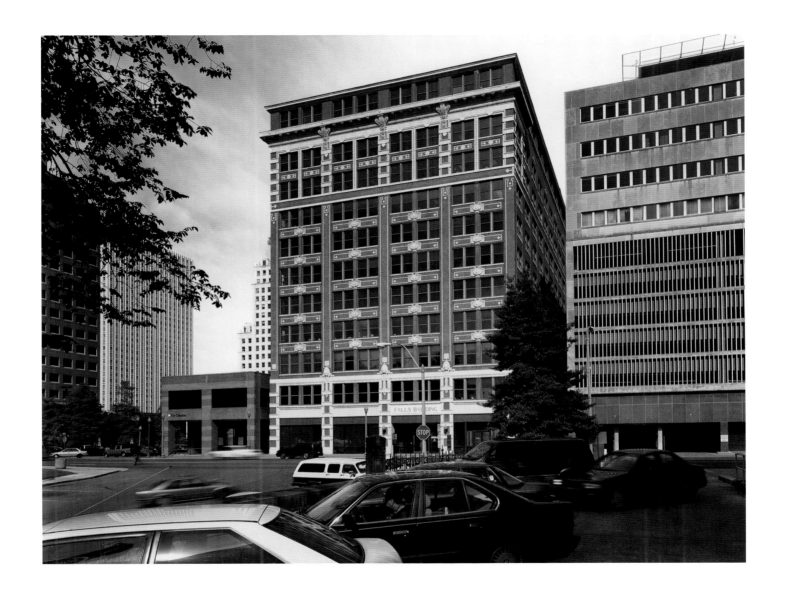

The Falls Building (1909, renovated 1984), Court Avenue at North Front, was the first high-rise office complex on Cotton Row designed for cotton merchants. On top of the Falls Building, the Alaskan Roof Garden was billed as "the coolest place in town" and was the site for the premiere of W. C. Handy's "St. Louis Blues." In contrast was Whiskey Chute, the short alley connecting Main Street to Front Street on the south side of the building, used to roll barrels of whiskey from the river to Main Street. The "Chute" had a sinful reputation. (1999)

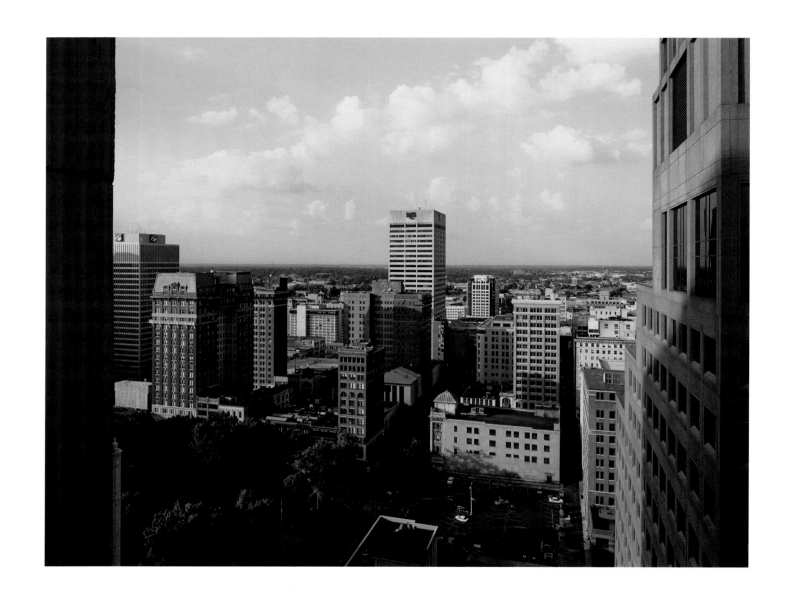

The D. T. Porter Building, 10 North Main at Court (the narrow building toward the center and one-third up from the picture bottom), is dwarfed by newer structures. When built in 1895 by the Continental Bank, the eleven-story marvel was the first steel-frame skyscraper in Memphis. (1999)

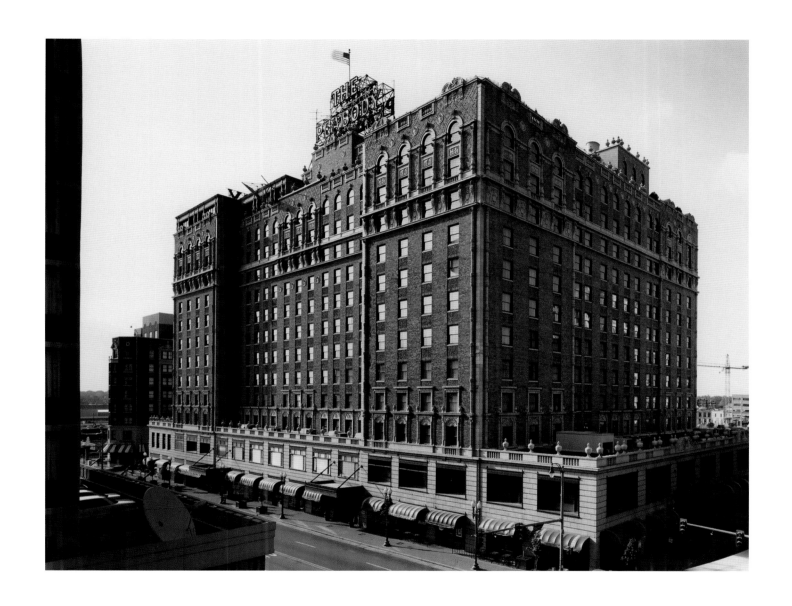

"The Mississippi Delta begins in the lobby of the Peabody Hotel in Memphis and ends on Catfish Row in Vicksburg," wrote David L. Cohn in 1935. The fabled landmark (1925, restored 1980) fills a block on Union Avenue between Second and Third streets. (1999)

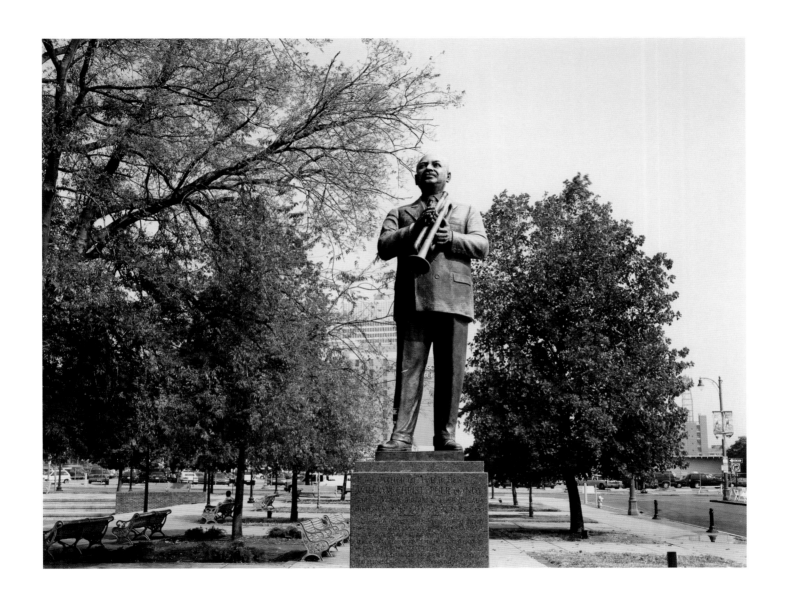

A statue of W. C. Handy was erected in 1960 in Handy Park, Beale Street at Rufus Thomas Boulevard. The park, dedicated in 1931, was previously the site of Beale Street Market. William Christopher Handy (1873–1958) was enormously influential in popularizing the blues. As the leader of a nine-piece dance band that played to upscale audiences, he got the idea of utilizing the earthy blues in his own musical compositions when he saw its great appeal to people and its potential to make money. His first such success was a composition he wrote in 1909 for E. H. Crump's Memphis mayoral campaign, later titled "Memphis Blues." (1998)

33

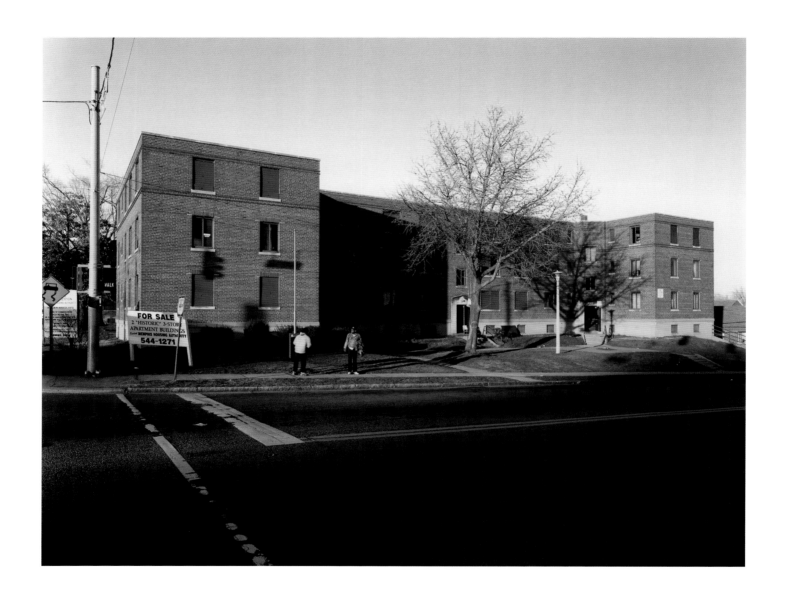

The first two public housing projects in Memphis, constructed simultaneously (1935–1938) and designed by the same architect, J. Frazer Smith, were Dixie Homes and Lauderdale Courts. Lauderdale Courts were meant for whites and Dixie Homes for blacks. Lauderdale Courts, viewed here from Exchange Avenue at Third, includes two three-story buildings on Third Street and a variety of one- and two-story buildings that stretch all the way to Danny Thomas Boulevard. Elvis Presley lived with his family at Lauderdale Courts from 1949 to 1953 in the three-story building at Third Street and Winchester. (1999)

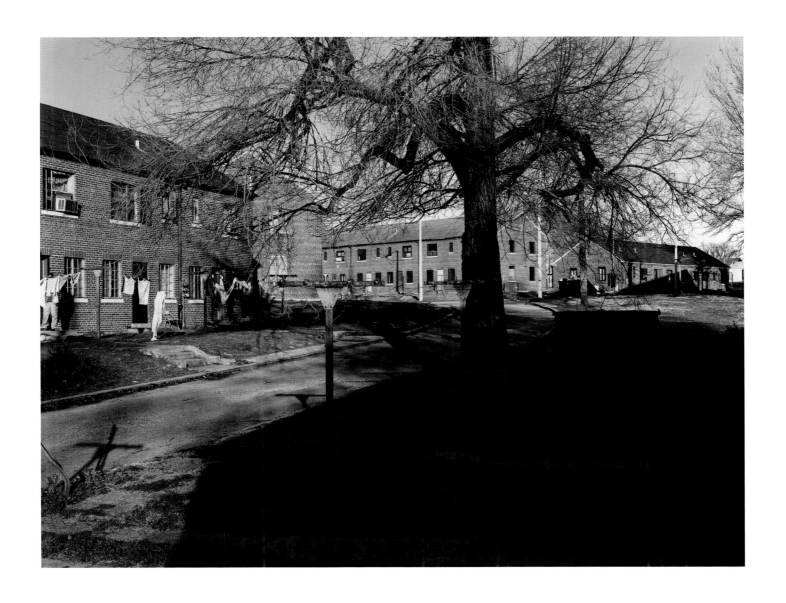

Another section of Lauderdale Courts stretches between Lauderdale Street and Danny Thomas Boulevard.
In 2000, the Memphis Housing Authority enlisted private developers to help transform Lauderdale Courts
into a mixed-income community—public housing, moderate-income, and market-rate units. (1999)

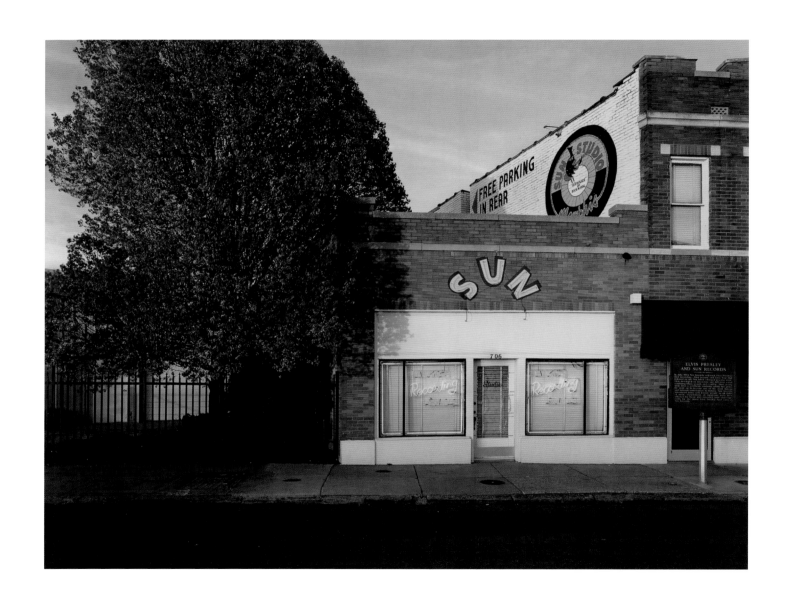

In the 1950s at Sun Studio, 706 Union Avenue, Sam Phillips discovered and recorded B. B. King, Howlin' Wolf,
Ike Turner, Rufus Thomas, Elvis Presley, Johnny Cash, Jerry Lee Lewis, Carl Perkins, Charlie Rich, Roy Orbison,
and others. Peter Guralnick asserts that, in so doing, Sam Phillips "provided the stylistic bedrock not just
for rock 'n' roll but for much of modern blues as well." The building was erected in 1916. (1999)

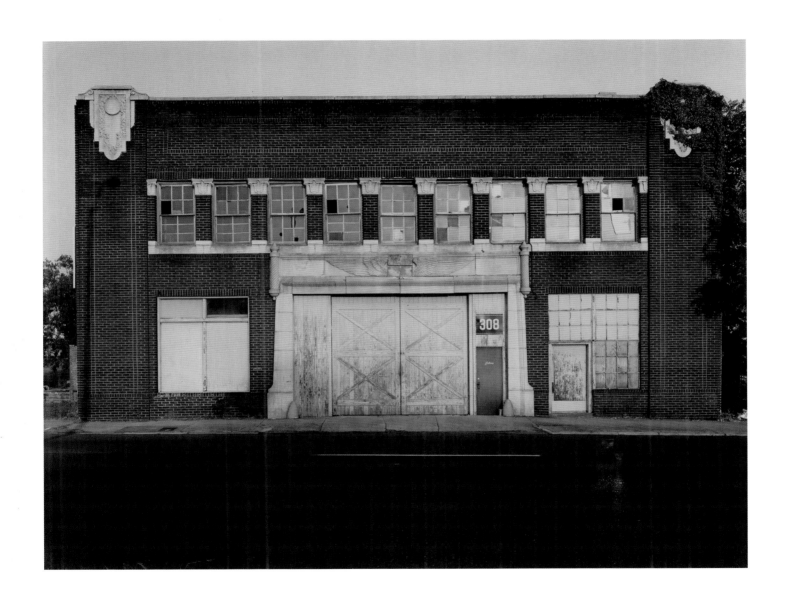

In the 1941 city directory, 308 South Second Street (built in 1930) was the address of Film Transit. By 1945, in the vicinity of South Second Street between Pontotoc and G. E. Patterson, there were fourteen theater supply and motion picture distribution businesses strategically located to serve Memphis and outlying movie theaters in Arkansas and Mississippi. (1999)

Smith Fixture Company (1910), 376 South Main Street, is a long-term business in the South Main Historic District, a historically mixed-use area that features such redevelopment. (1999)

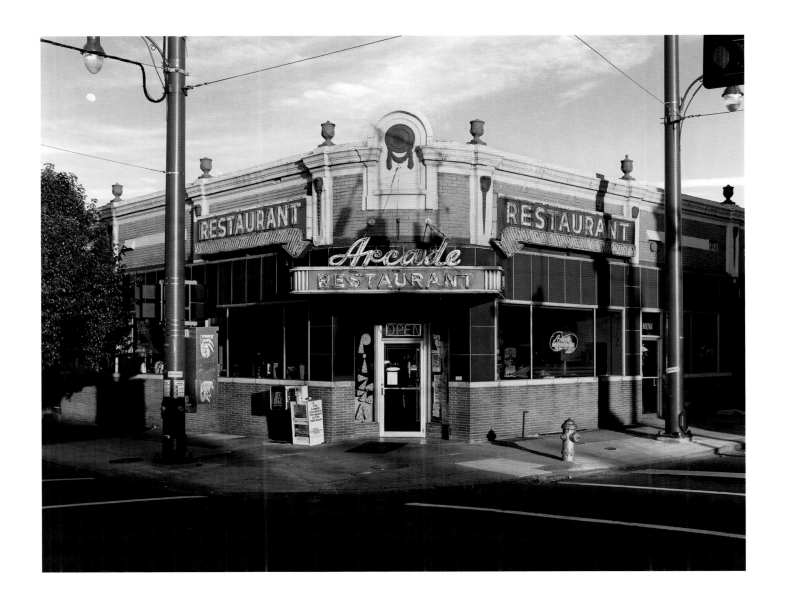

The Arcade Restaurant (c. 1915, facade remodeled 1954), located at 540 South Main and G. E. Patterson Street in the South Main Historic District, is the only remaining Memphis diner, and the signage is vintage neon. (1999)

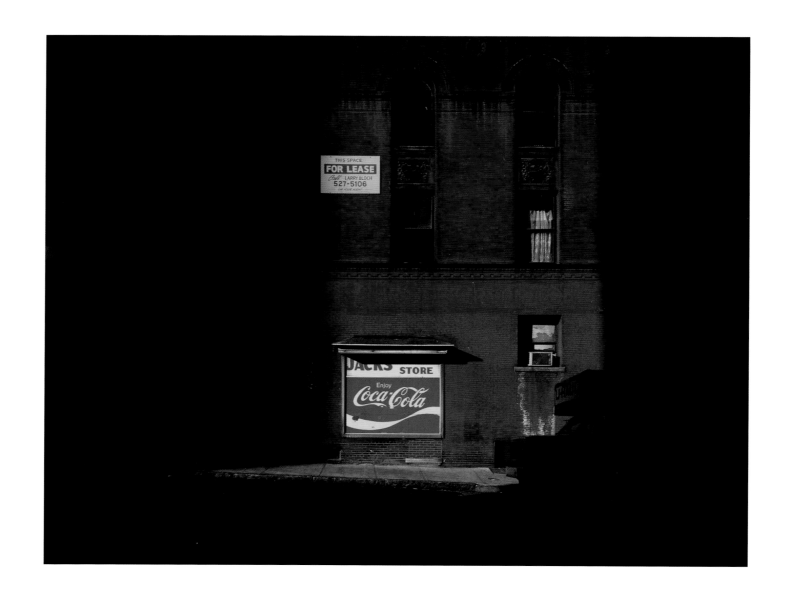

Jack's Food Store (1880), which fronts Main Street, is viewed here from the Jefferson Avenue side of the building. Jack's is the only historic grocery still operating downtown. (1999)

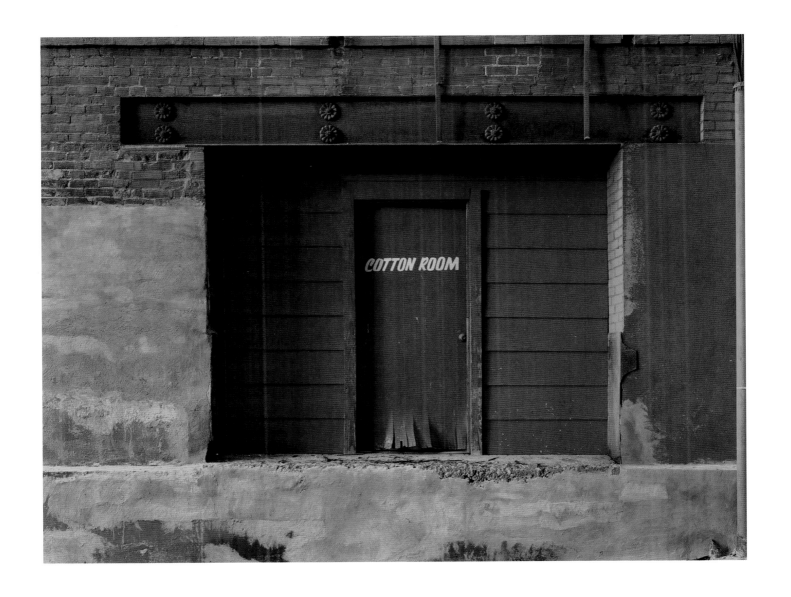

This loading dock, once used by the F. G. Barton Cotton Company, is on Gayoso Avenue between Front Street and Wagner Place. (1999)

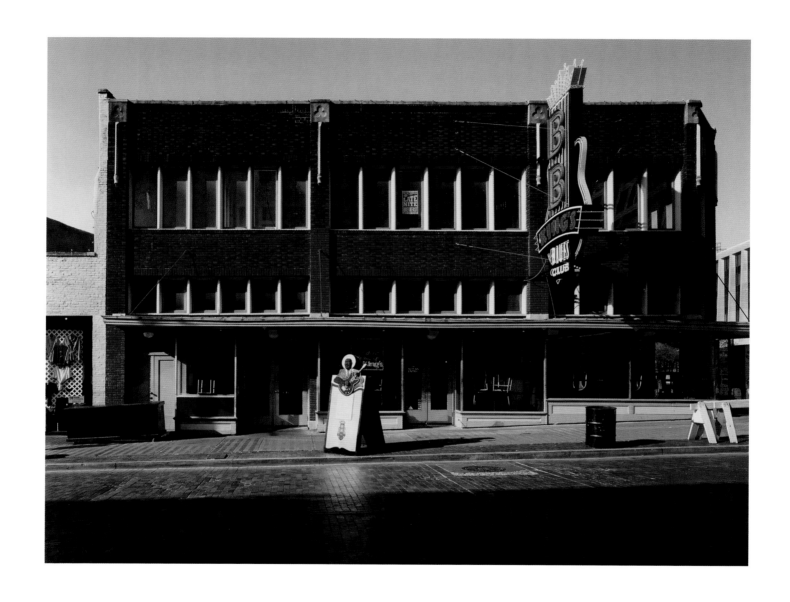

B. B. King's Blues Club, 139–145 Beale Street at Second Street, opened in 1991. B. B. King, who began his professional career in the original Beale Street environment and Memphis music scene, is now one of the most recognized blues artists. His namesake club is a big player on the street, and King still makes periodic performances there. When first built in 1924, the building was used by both F. L. Schwantz and Company (grocers) and Sigmund Feder Brothers (clothing). (2001)

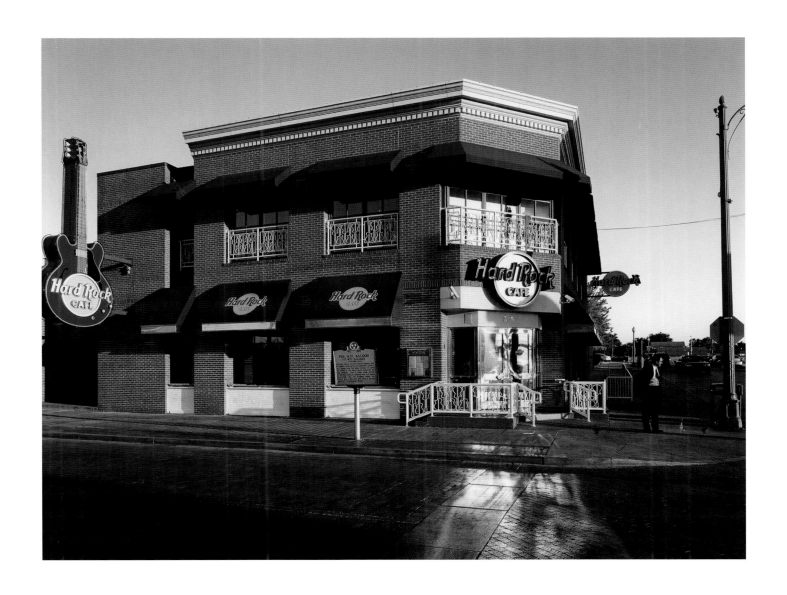

The Hard Rock Cafe opened here in 1997, at 315 Beale Street and Hernando Street, the previous site of the famous
P. Wee's Saloon. In 1909, according to legend, W. C. Handy wrote the song "Mr. Crump," later immortalized as
"Memphis Blues," on the saloon's cigar counter. In a 1996 Mojo *interview the Rev. A. D. "Gatemouth" Moore observed,*
"For a long time even the black people looked down on the blues. It wasn't middle-class. Then Elvis Presley came along,
twisting and singing and everything . . . and we were making all kinds *of money. I ain't got no problem with that." (2001)*

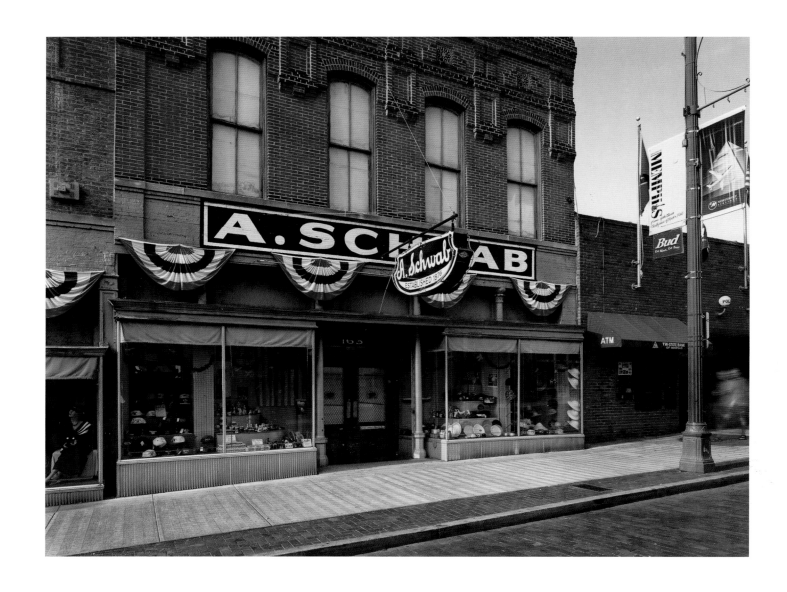

A. Schwab, 163–165 Beale Street, is considered the oldest operating general store in the city, and the buildings are typical of the late-nineteenth-century commercial architecture on both sides of the street before the 1969 Beale Street Urban Renewal Program bulldozed over five hundred buildings. The Schwab family business had been on Beale Street since 1876. In 1912 it moved to 163 Beale (built about 1865), and in 1924 it expanded to 165 Beale. The buildings, displays, and merchandise still give a sense of the old Beale Street. (1998)

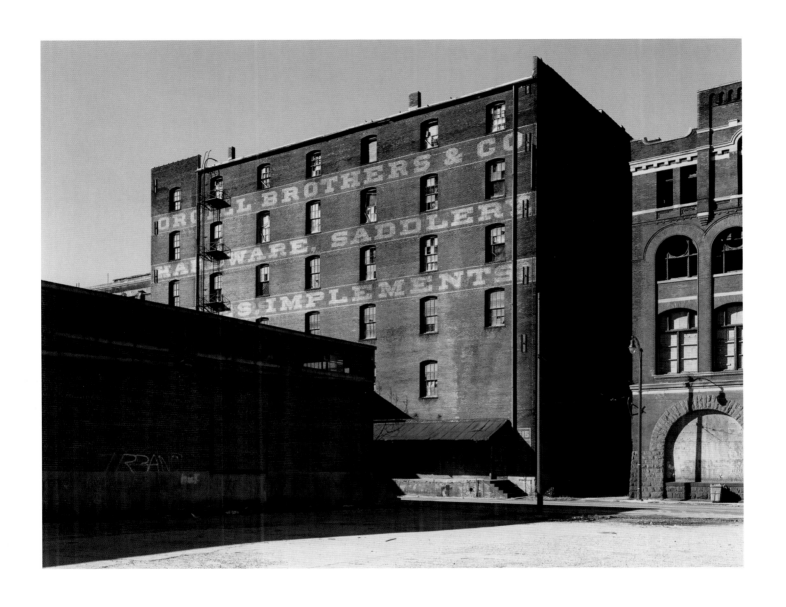

The Orgill Brothers & Co. Building (1900) is located at 505 Tennessee Street. The Orgill family connection with Memphis began in 1847. The six-story building was one of a four-building complex, totaling 344,000 square feet, that the company gradually acquired and adapted for its use. In 1953, the company built an additional 600,000-square-foot warehouse at 2100 Latham Street in South Memphis. Edmund Orgill gave up his presidency of the company to serve as mayor of Memphis from 1956 to 1960. The building is being converted into lofts. (1999)

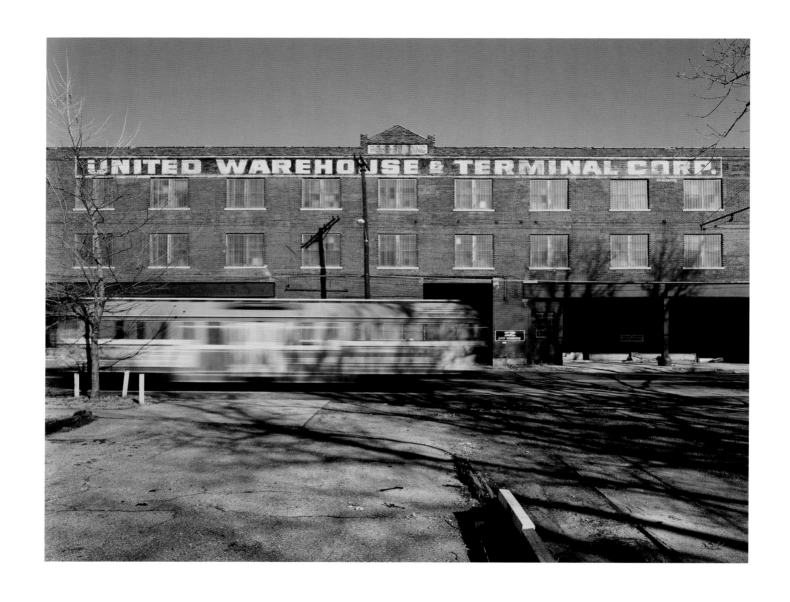

The United Warehouse and Terminal Corp. (originally Rose Building, 1925) is located at 2 G. E. Paterson Street.
The passing trolley is one of about a dozen antique cars bought and restored for use on the Main Street Trolley
and Riverfront Loop Trolley routes that began service in 1993. (1999)

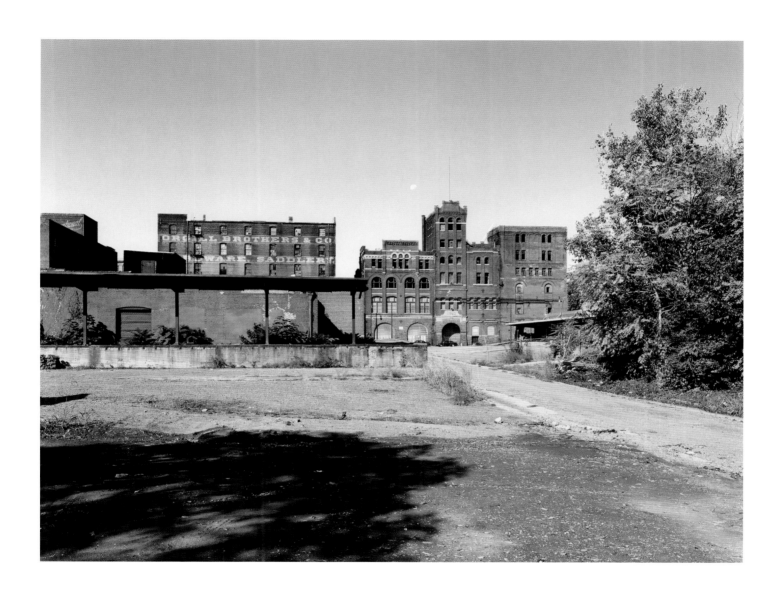

In the right background of this view from Front Street is the Tennessee Brewery Company (477 Tennessee Street), founded in 1890 by John W. Schorr, whose family had brewed beer in Germany for five hundred years. The building was made from a kit from Germany that came complete with a brewmeister. In 1887, pure artesian water was discovered in the area, ultimately saving the city from disease and becoming one of its greatest assets. The artesian water, which had an ideal temperature for making beer, contributed much to the success of the brewery. It closed in 1954. (1998)

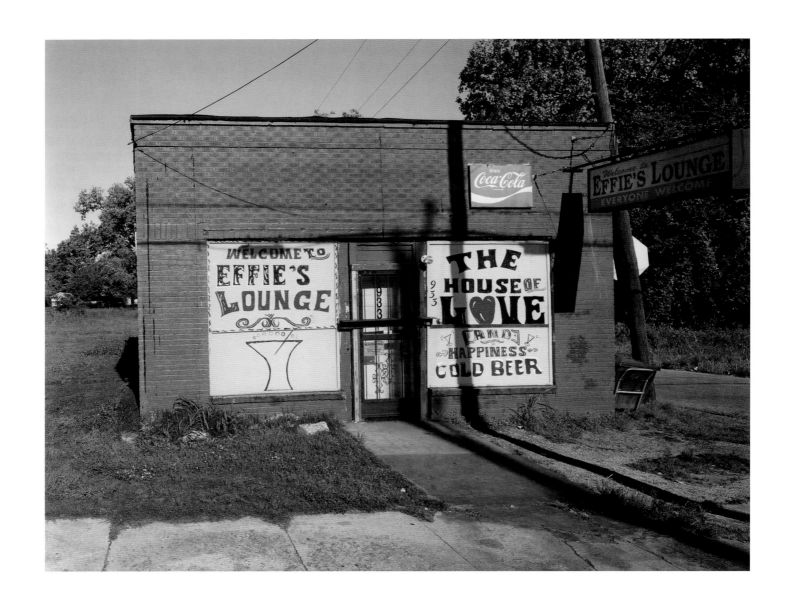

Effie's Lounge, 933 North Second Street at Hickory, borrows its logo, "Love and Happiness," from the title of a song by Al Green, the well-known gospel and soul musician, who also founded and is pastor of the Full Gospel Tabernacle (page 71) in Memphis. (1999)

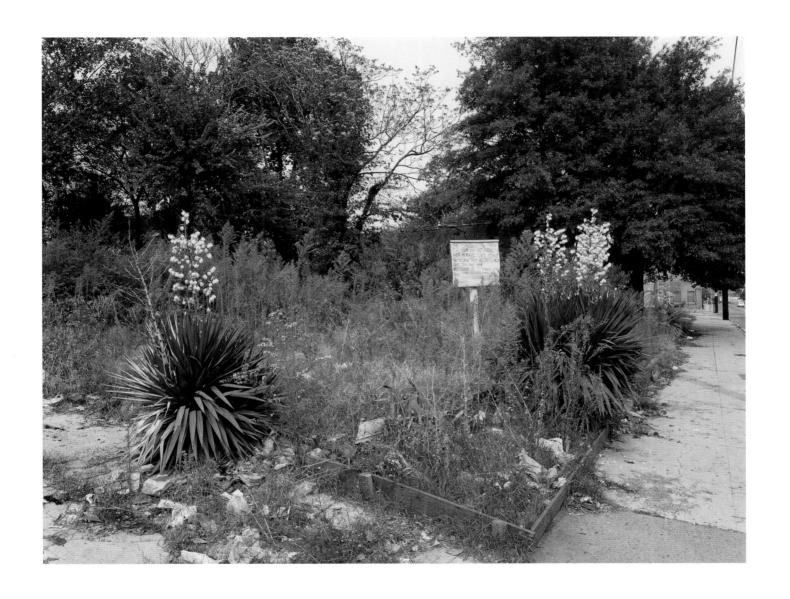

The sign in this overgrown vacant lot on South Fourth Street between Vance and Pontotoc avenues is a death notice for Mary Tinnon. It says: "THE ORIGINAL Mrs. MARY / IS GONE BUT NOT FORGOTTEN / HER MEMORIES LIVES ON! / THE WOMAN THAT HELPED SO MANY / DIDN'T TURN AWAY ANY!" *It then gives the times and places of the wake and funeral. (2000)*

Collard greens are coming up in the vacant lot used by Mary Tinnon, who lived across the street, for her garden.
The red brick building is an abandoned apartment. The bell tower of St. Patrick's Catholic Church is in
the background on the right, and Clayborn Temple is in the background on the left. (1999)

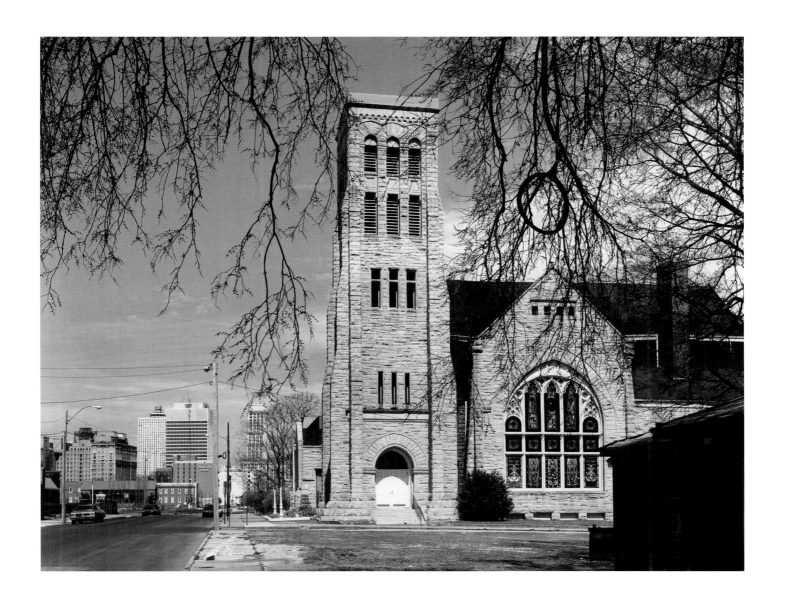

*Viewed here from Hernando Street at Pontotoc Avenue, Clayborn Temple (originally Second Presbyterian Church, 1891)
was the spiritual and logistical center and the main rallying point for the 1968 sanitation workers' strike
that brought Martin Luther King, Jr., to Memphis and to his tragic death. (1999)*

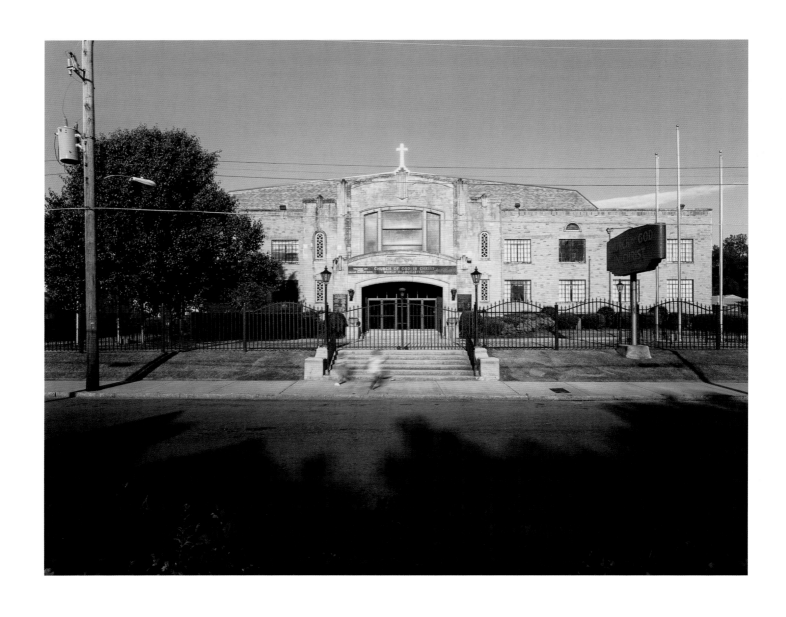

Mason Temple, 930 Mason Street in the South Memphis district, was built in 1940 and restored in 1991. It is the center of the World Headquarters complex for the Church of God in Christ. It was in this building that Martin Luther King, Jr., gave his "I Have Been to the Mountaintop" speech the night before his assassination. (2001)

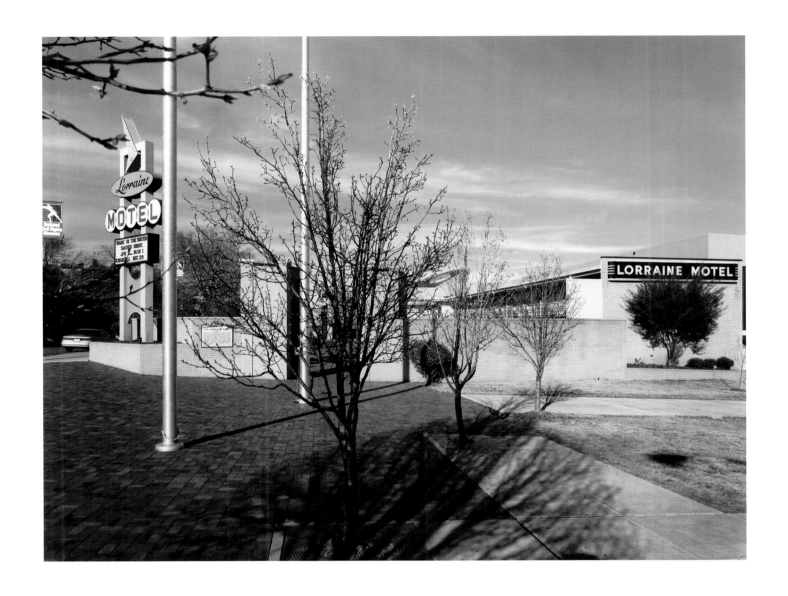

The Lorraine Motel (1925–1964), located on Mulberry Street at Butler Avenue in the South Main Historic District.
The National Civil Rights Museum is now housed at the Lorraine, where Martin Luther King, Jr., was assassinated.
In his 1963 book Strength to Love, *King wrote: "I am convinced that the universe is under the control of*
a loving purpose, and that in the struggle for righteousness man has cosmic companionship.
Behind the harsh appearance of the world there is a benign power." (1998)

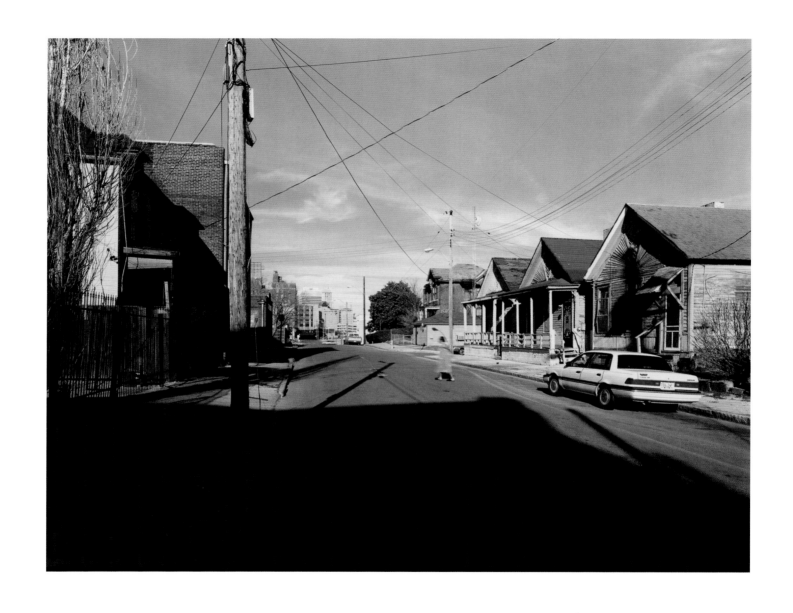

Mulberry Street runs through downtown Memphis's South Main Street Historic District.
The three shotgun houses on the right were built about 1895. They were renovated (page 55)
in keeping with the gentrification taking place in the historic district. (1998)

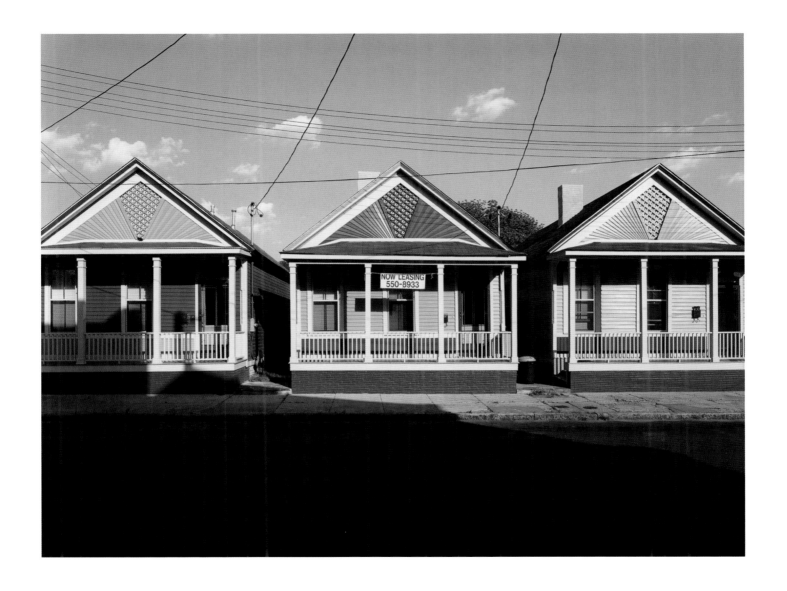

Shotgun houses, which are built one room wide and two or more rooms deep, have a distinct narrow appearance.
They have traditionally housed lower-income blacks and whites in the South. In Memphis: An Architectural Guide,
Eugene Johnson points out that both W. C. Handy and Elvis Presley were born in shotgun houses. (2001)

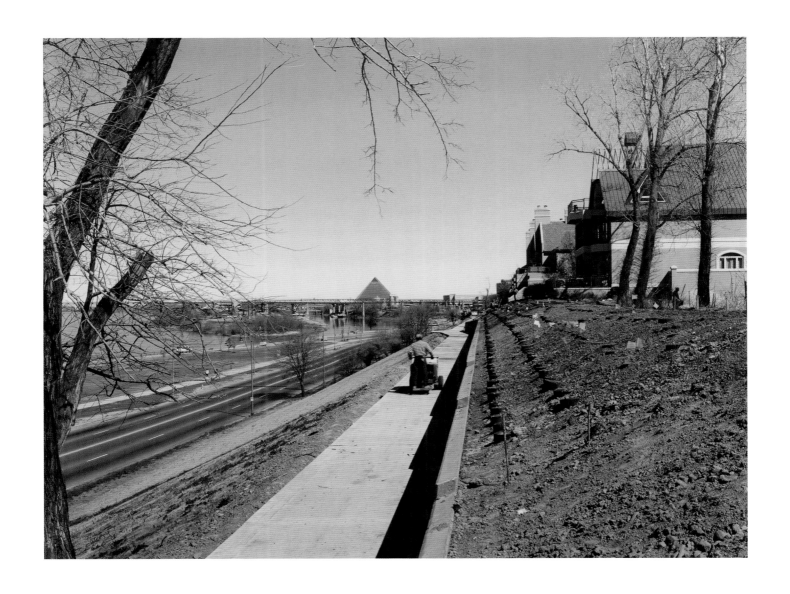

A stretch of the Mississippi Riverbluff Walkway during construction. To the left,
a section of Tom Lee Park can be seen between the river and Riverside Drive. (1999)

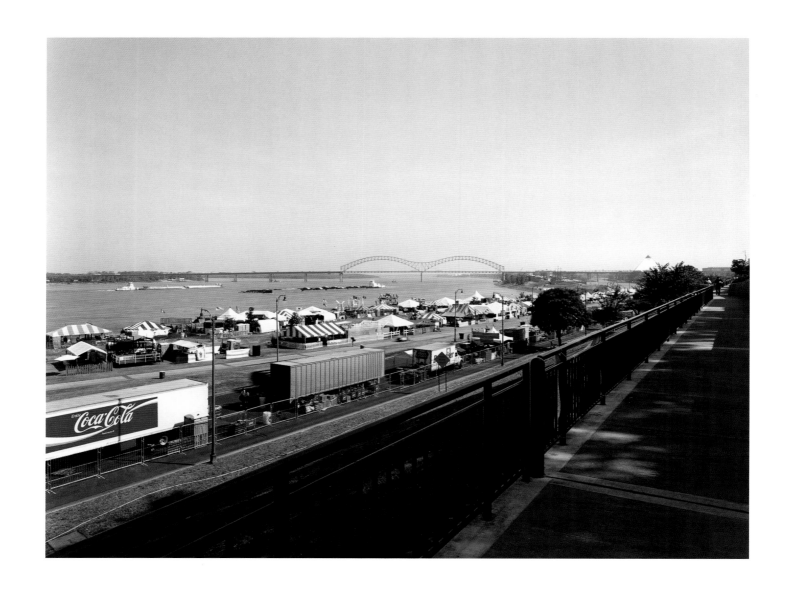

In this view north from the Mississippi Riverbluff Walkway, tents and cooking apparatus are being set up in Tom Lee Park for over 250 teams to compete in the 2001 Memphis in May World Championship Barbecue Cooking Contest. The Memphis in May International Festival is a month full of events to celebrate the local culture and introduce foreign cultures to Memphians. The honored country for 2001 was the Netherlands. The barge tow on the left is going upriver and the middle one is coming downriver. (2001)

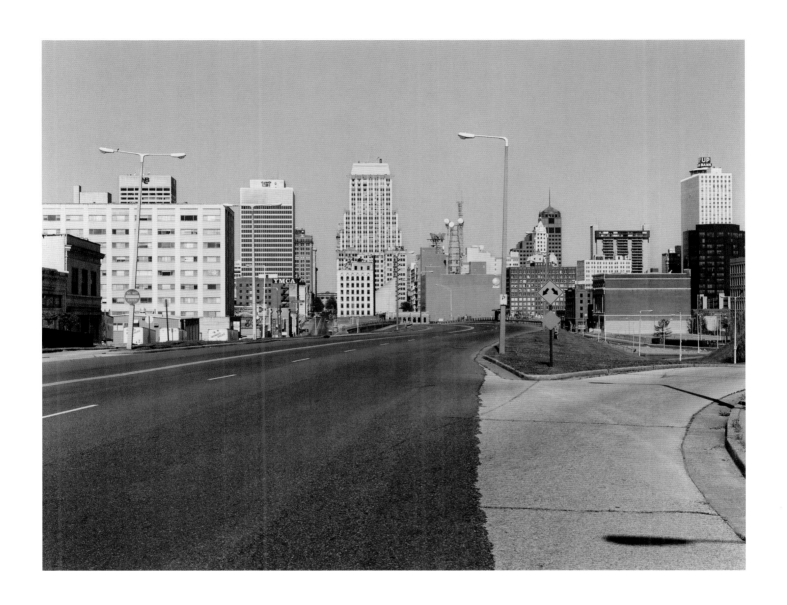

*In the center of this view of downtown, the pale yellow neo-Gothic Sterick Building, with twenty-nine floors,
was the tallest in the South when it was built in 1930 on the northeast corner of Madison Avenue
and Third Street. The white building on the far right, the 100 North Main Building,
with thirty-eight floors, is now the tallest in Memphis. (1999)*

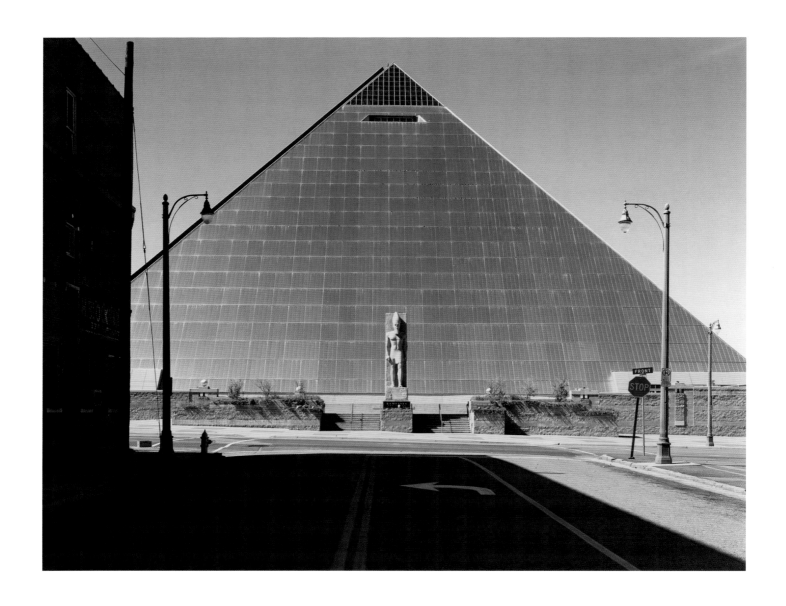

The Pyramid (1991) dominates the view from Overton Avenue at Front Street. A joint project of the Memphis and Shelby county governments, costing $70 million, built on a base the size of five and one-half football fields and rising thirty-two stories (321 feet) high, the Pyramid is a 22,500-seat sports and entertainment facility. The statue is a replica of the original Egyptian statue believed to depict Rameses II, known as Rameses the Great. (1996)

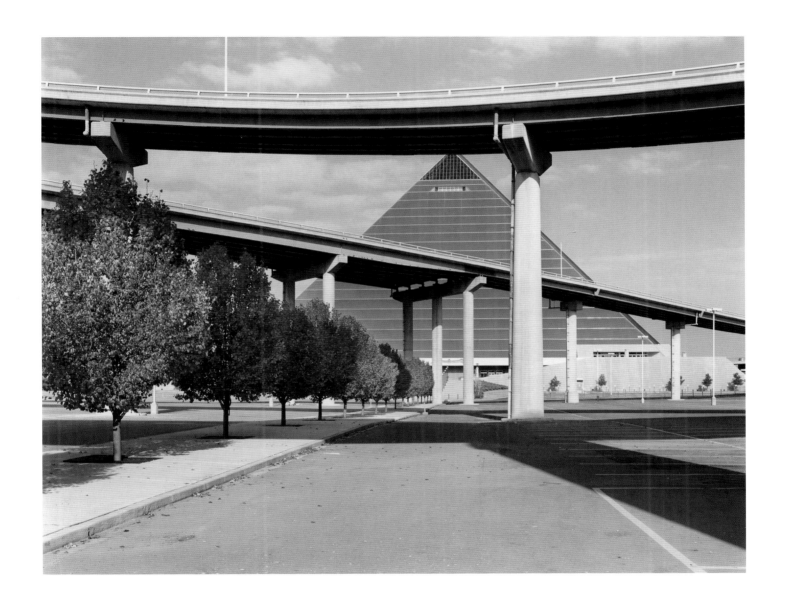

The Pyramid and I-40 bridge ramps crisscross the view from the Pyramid's south parking lot. From 1844 to 1851, this area—bounded by North Front Street, Auction Avenue, the I-40 bridge ramps, and the Wolf River Lagoon— was occupied by a U.S. navy yard. The yard produced only one ship, the Allegheny, *which turned out to be a $500,000 failure. Nevertheless, the navy yard had a positive effect on the early Memphis economy. (1996)*

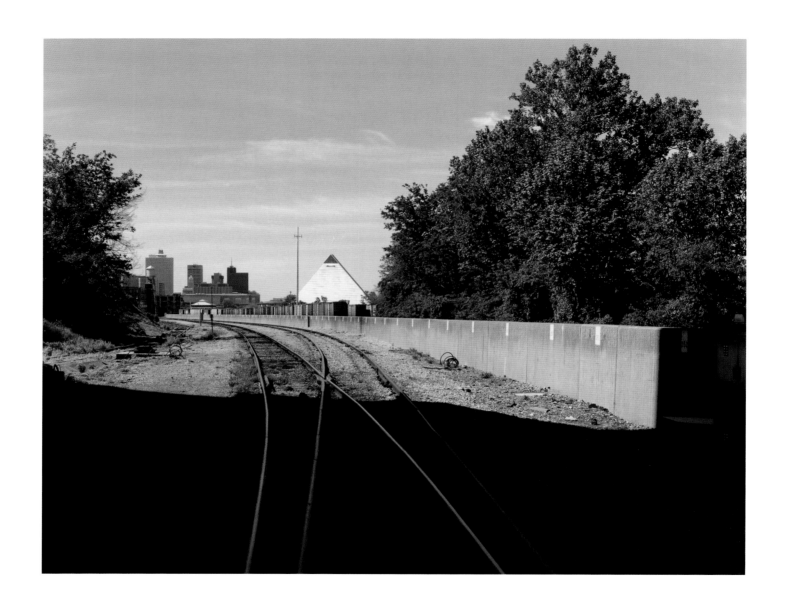

Along the Illinois Central tracks near the Marble Bayou pumping station, a concrete floodwall protects against high Mississippi River water backed up into the Wolf River Lagoon just to the right. The Wolf River, on the north side of Memphis, and Nonconnah Creek, on the south side, flow into the Mississippi River; their water level is affected by its water level. Now, levees and floodwalls prevent these two tributaries from flooding the city. Drainage structures, storage reservoirs, and pumping stations provide the means to remove the city's interior drainage and sewage. (1999)

This house (1940) once stood at 5108 Truse Street. Clark Tower, 5200 Poplar Avenue (1971), is in the background.
A Home Depot now occupies the site. The home was part of the Truse-McKinney neighborhood, a poor, black
enclave of about seventy houses in a twenty-acre area surrounded by upscale commercial development.
In 1985 the neighborhood put together a coalition of blacks and whites, residents and professionals,
to sell their community as a twenty-acre tract. Twelve years later the landowners received more than
they would have by selling individually, enough to buy new places to live. (1996)

63

This bungalow was built in 1929 on Oliver Avenue in the Cooper Young neighborhood of Midtown. The Midtown district is made up of primarily residential neighborhoods that were suburbs developed east of downtown at the turn of the twentieth century. Midtown contains a great diversity of architecture. Its population also represents a wide range of incomes and ethnic backgrounds. (1998)

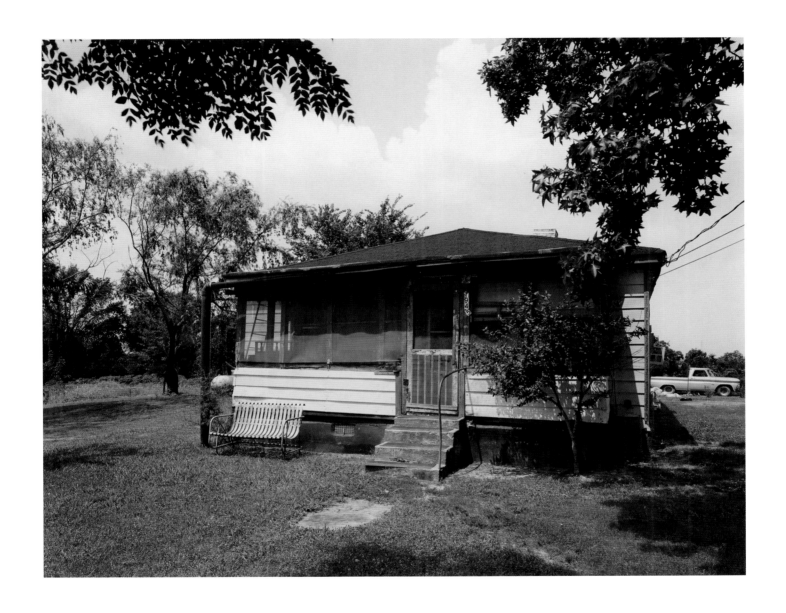

This house was built in 1920 in the Boxtown neighborhood of Memphis, just south of T.O. Fuller State Park.
Local legend has it that a porch ceiling painted blue brings the owner good luck. (1991)

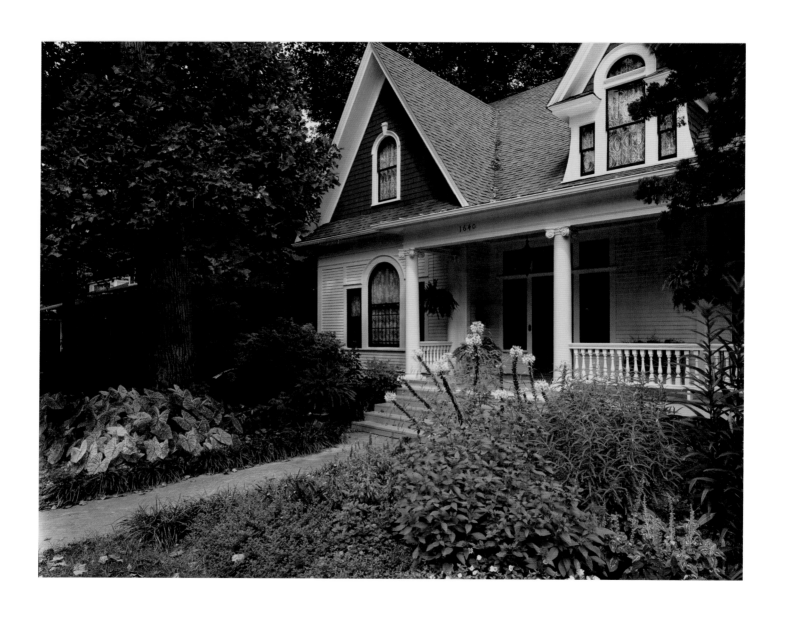

This cottage, built in 1907, is on Forrest Avenue in the Evergreen neighborhood in Midtown. (1998)

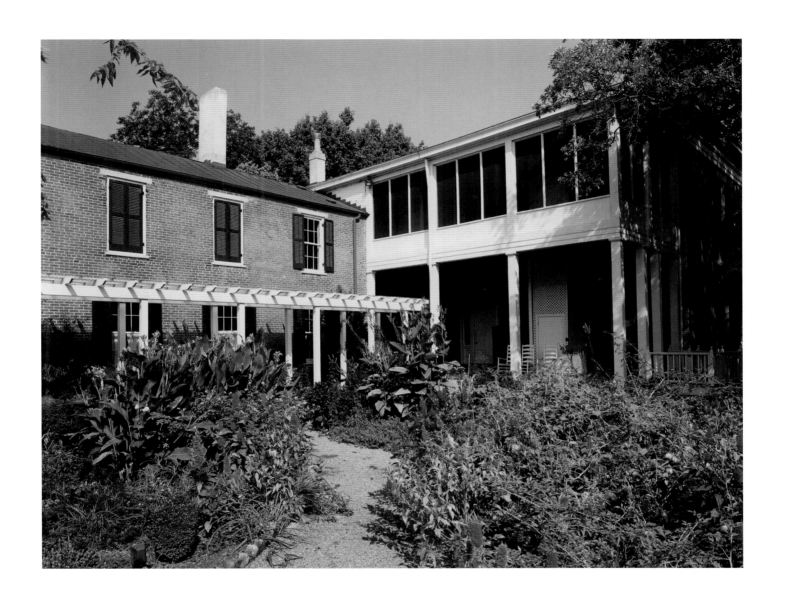

A flower garden grows at the rear of Hunt-Phelan House (1830s–1855) at 533 Beale Street.
This antebellum mansion served as Gen. Ulysses S. Grant's headquarters in 1862
during the Union occupation of Memphis. (1998)

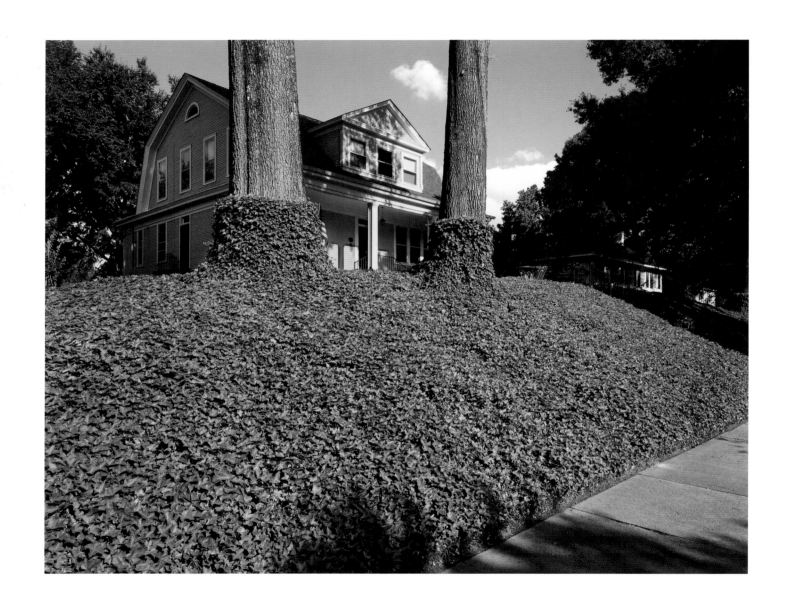

An ivy bank dominates the front yard of this 1903 house on Belvedere Boulevard in the Central Gardens neighborhood in Midtown. The gambrel roof is indicative of the Dutch Colonial Revival style. (1998)

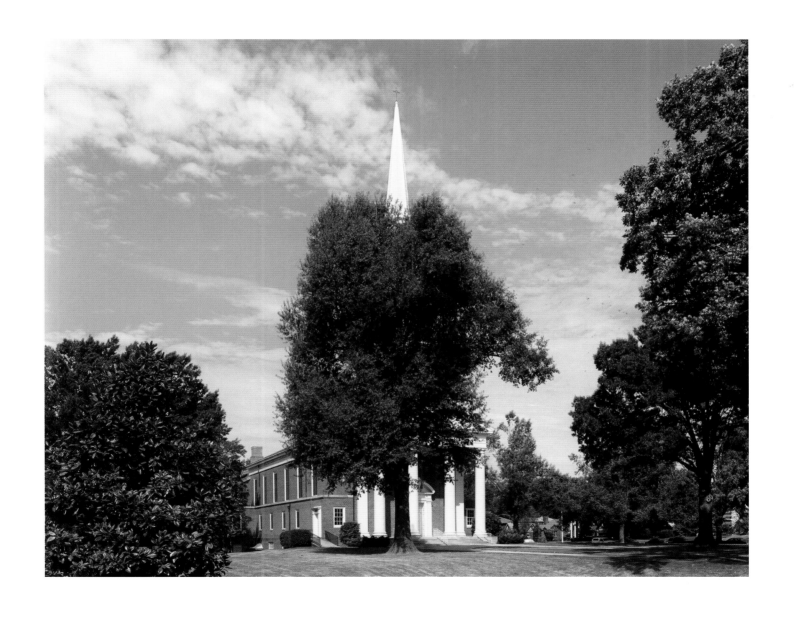

Evergreen Presbyterian Church (1951) is in the Evergreen neighborhood in Midtown,
opposite Rhodes College on University Street. (1998)

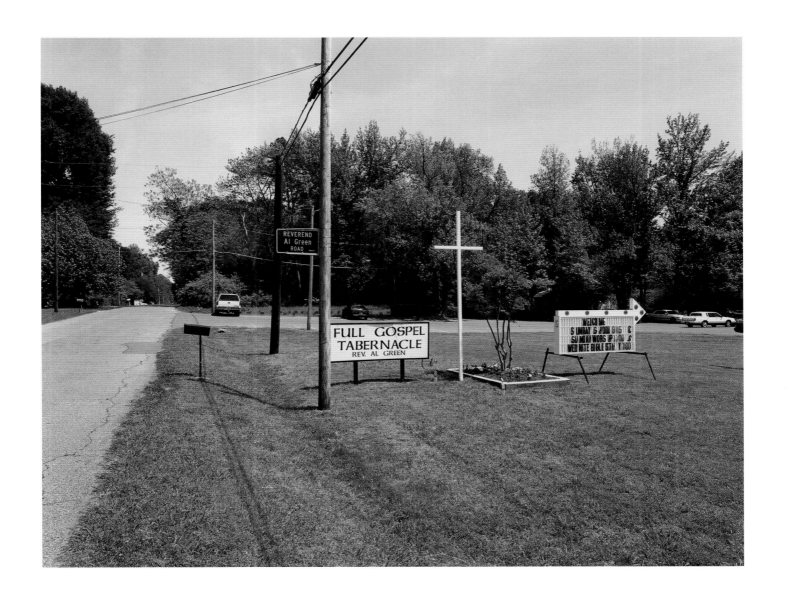

Signs in the front yard of the Full Gospel Tabernacle on Hale Road direct visitors to the church founded and pastored by Rev. Al Green, the well-known gospel and soul musician. This church, located in Whitehaven about two miles from Graceland, is visited by people who come from all over to hear Al Green preach and sing during the service. (2001)

This house, built in 1975, is in the Valley Wood neighborhood in the Whitehaven district. (2001)

This Tudor-style house, built in 1940, is in the Hedgemoor neighborhood in the University district. (1998)

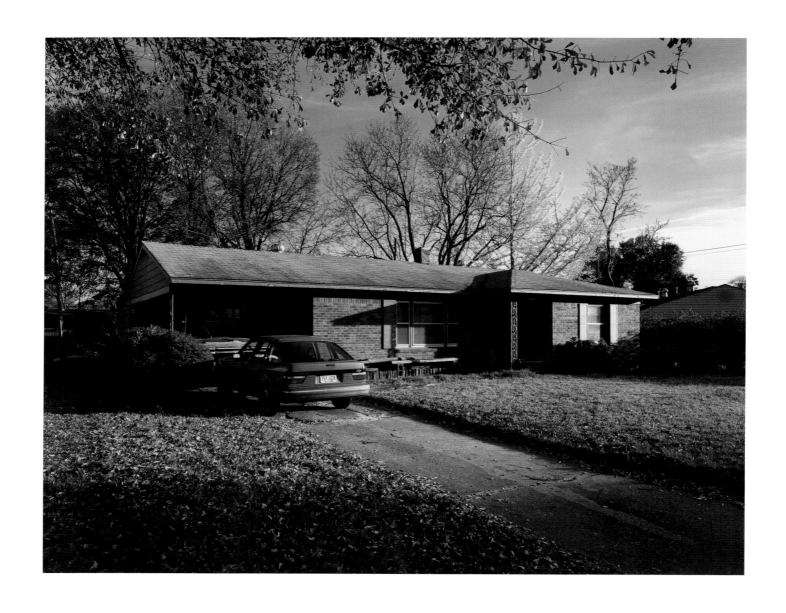

This classic ranch-style house, built in 1956, is in the Sea Isle neighborhood in the Quince district. (1998)

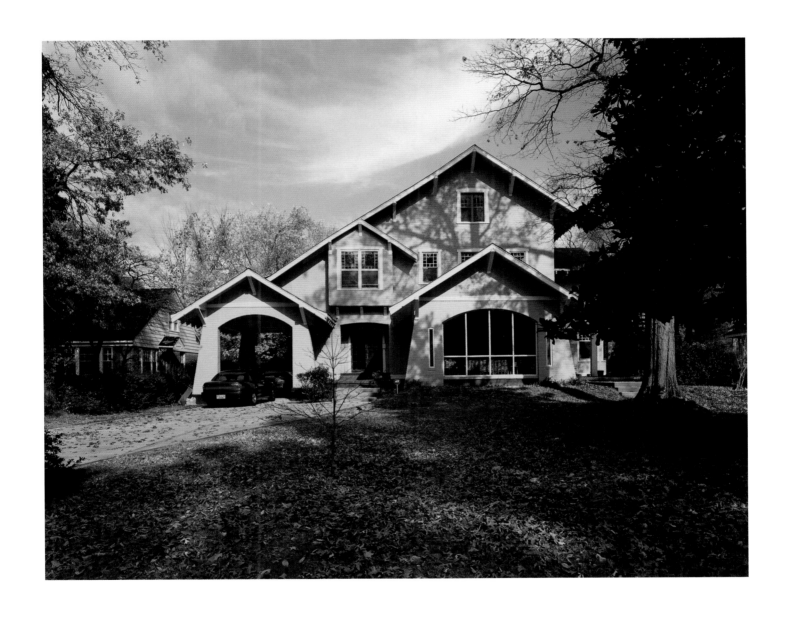

This house, built in 1916 in the Arts and Crafts style, is in a nicely treed section on South Parkway East in the Midtown district. (1998)

The house on the left, now at 1616 Central Avenue in the Central Gardens neighborhood of Midtown, was one of the earliest built in the area. It was built in 1853 by William R. Harris on forty acres purchased from the Solomon Rozelle family, large landowners who farmed the area with the help of slaves. The house originally had clapboard siding; the brick veneer was added in 1910. William's brother, Isham G. Harris, was governor when, during the Civil War, Tennessee seceded from the Union. The house on the right was built in 1920. (1998)

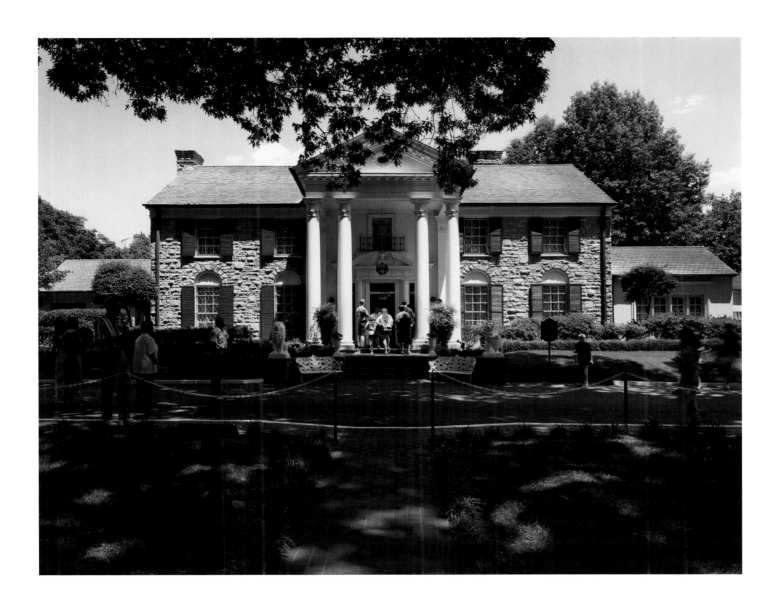

Graceland Mansion, 3797 Elvis Presley Boulevard, in the Whitehaven district of Memphis, was built in the Southern Colonial style in 1939 for Dr. and Mrs. Thomas Moore. Elvis bought the mansion and the fourteen acres it occupied in 1957, when he was 22, for $100,000. It is now the second most-visited house in the United States, after the White House. In 2000 admissions revenue at Graceland was $15 million. (2001)

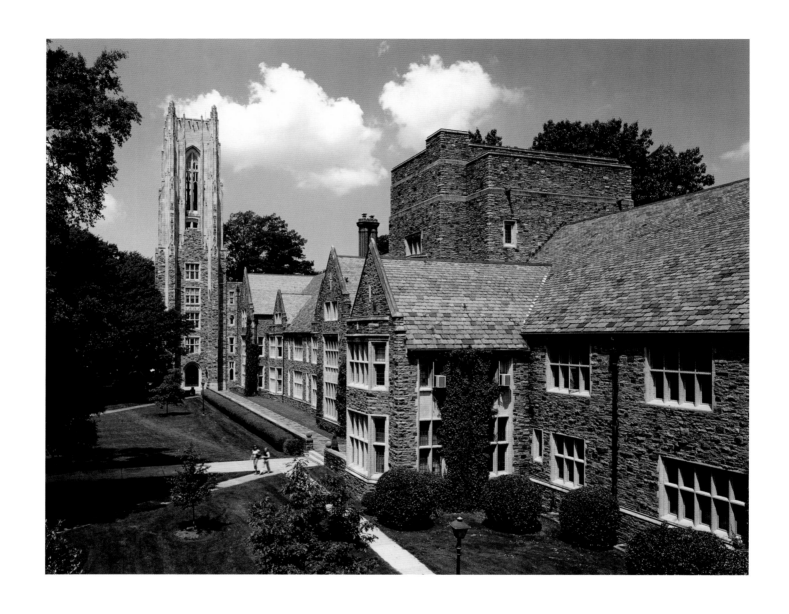

Rhodes College is located on a hundred-acre campus north of North Parkway and west of University Street in the Evergreen neighborhood of Midtown. Since the original construction in 1925, the college has maintained the continuity of its expansions by consistently using the Gothic Revival style and stone from one quarry. The main college building, Palmer Hall, in the foreground, was the first built. Halliburton Tower, farther back on the left, was added in 1961. (2001)

This strip of North Parkway near Evergreen Street was once the site of the Speedway, a mile-long amateur horse-racing track between Stonewall and University streets, built in 1905 by the Park Commission. The perfectly level, straight track was fifty feet wide with driveways at the sides for regular traffic, which were separated from the track by strips of grass, trees, and flowers. (2001)

*In this view from Overton Park, Poplar Avenue commuters are on the left, a golf course on the right. In 1901
the city acquired two large wooded tracts at what were then the southwestern and northeastern corners of the city
to make them into parks. The park on the west at the river is now called Martin Luther King, Jr., Riverside Park.
The eastern park is called Overton Park, after John Overton, a founder of Memphis. Landscape architect
George Kessler (1862–1923) designed both parks and a parkway system to connect them. (1998)*

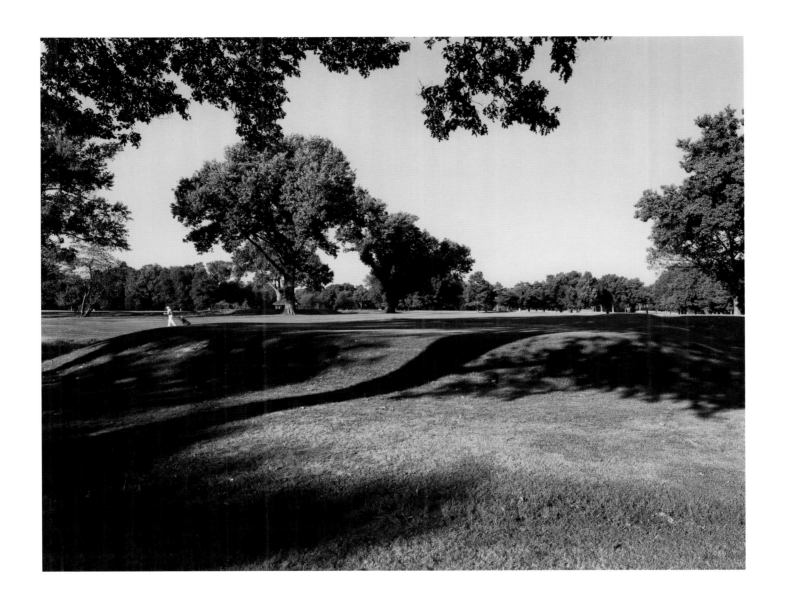

A summer morning at Galloway Park Golf Course in the University district. The Memphis area was once a magnificent hardwood forest, which began to be harvested during the late nineteenth century. Memphis had achieved its status as the world's largest inland cotton market by 1850, and by 1900 it had also become the world's largest hardwood market. The city is notable for the presence of trees throughout the landscape. When flying into Memphis, one still sees a blanket of green treetops. (1998)

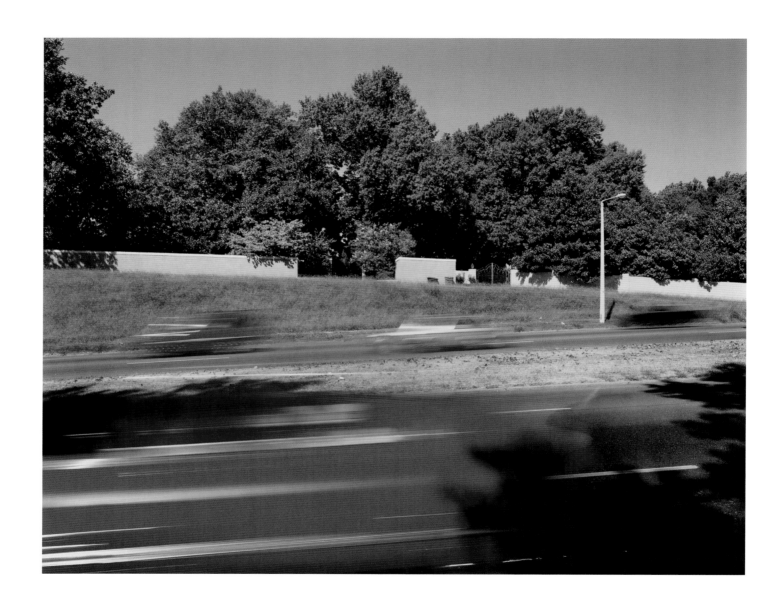

In 1902, when Riverside and Overton parks were designed, a parkway system was planned to connect them.
This seven-mile-long route of wide greenbelt boulevards became South Parkway and East Parkway, seen here. (1998)

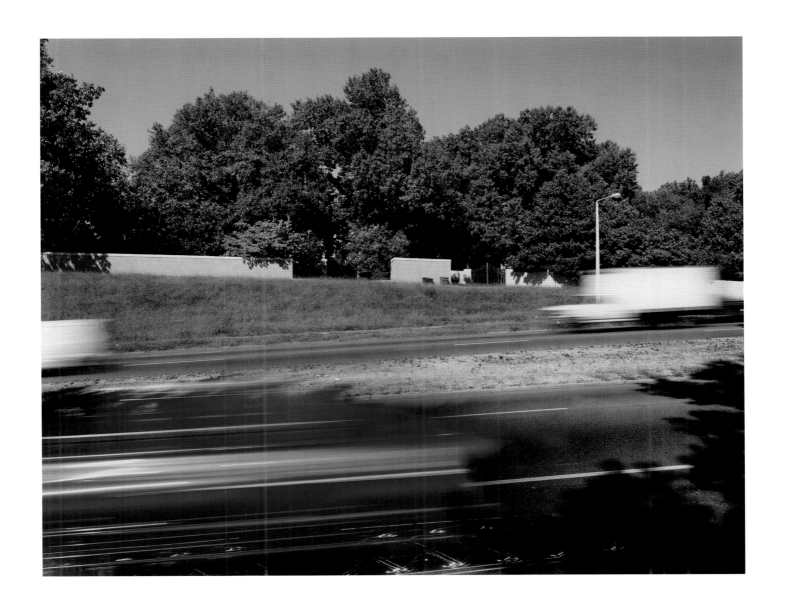

The roadway, including the Speedway, that would later become North Parkway was upgraded and added to the system in 1955. The parkways now form a loop corresponding to Memphis's 1909 boundaries. (1998)

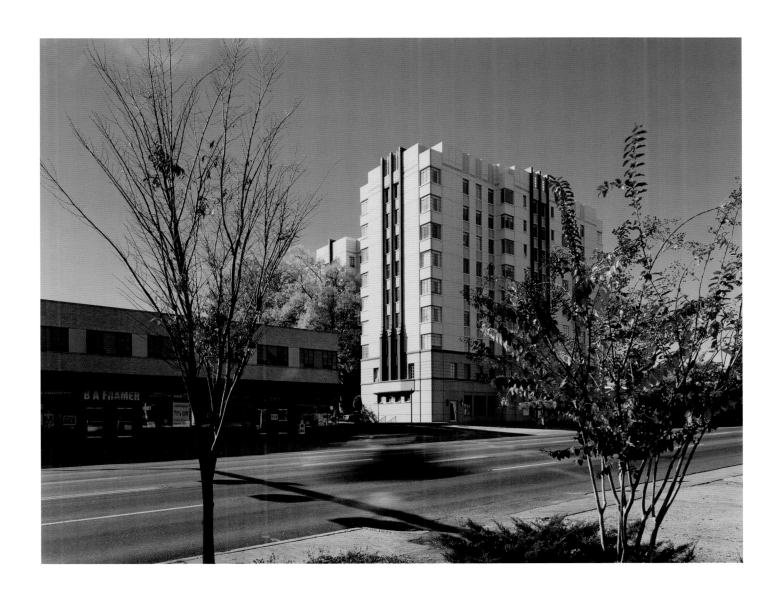

The Kimbrough Towers apartment building (1939) on Union Avenue at Kimbrough in Midtown is one of the best examples of Art Deco architecture in Memphis. (1998)

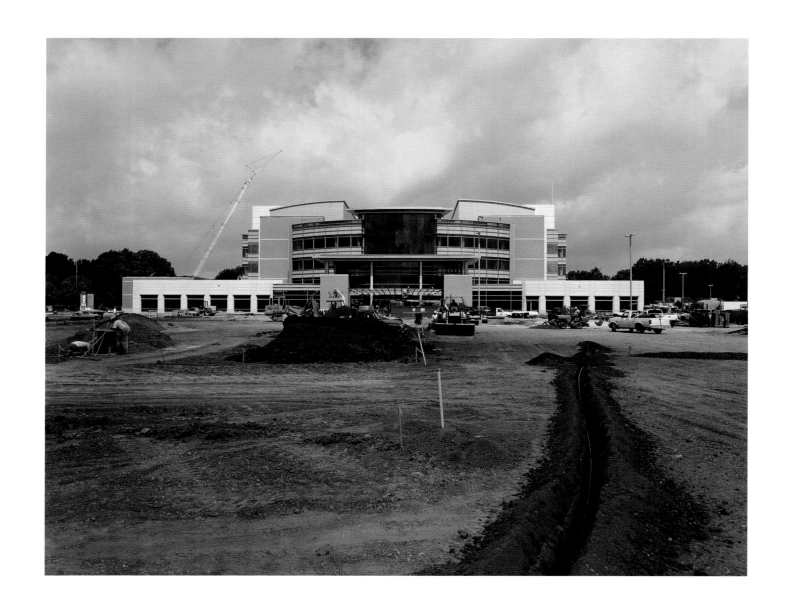

*The new Central Library at 3030 Poplar Avenue in the University district
will have 330,000 square feet of building space and 533 parking spaces. (2001)*

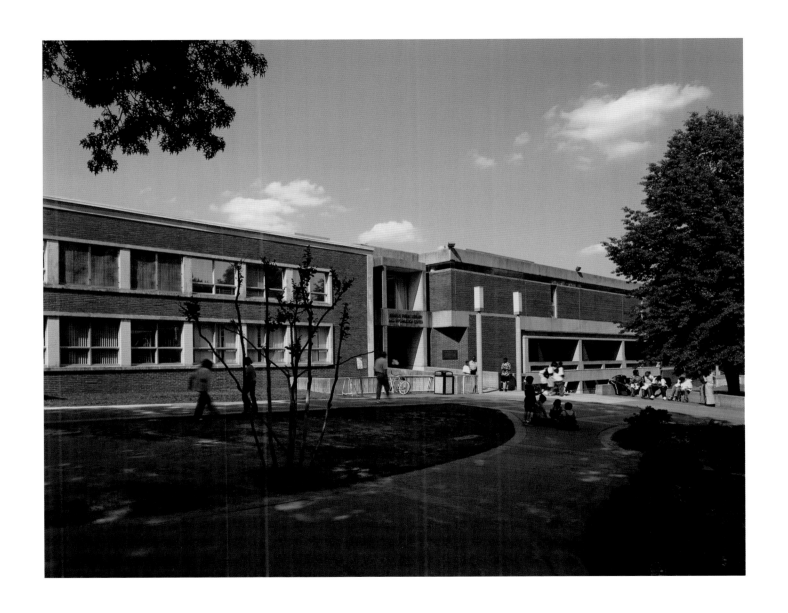

The old Main Library, at 1850 Peabody Avenue and South McLean Boulevard in Midtown,
opened in 1955, was greatly expanded in 1971, and ended up with 147,000 square feet
of building space and 110 parking spaces. (2001)

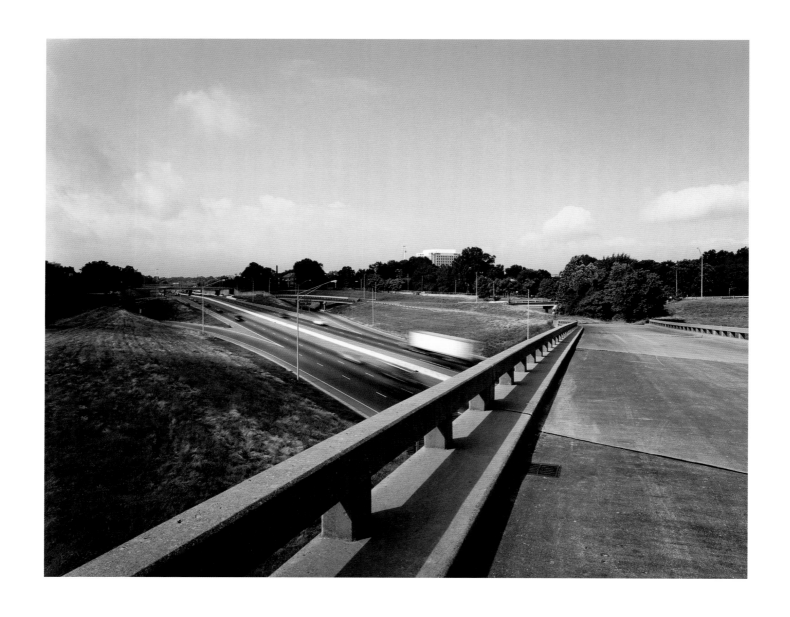

*On this section of the Interstate 40-240 loop at the western I-40 interchange, the ramp in the right foreground
has never been used. Initially, I-40 was planned to go straight through the city, including Overton Park
in Midtown. A group opposed to that proposal formed Citizens to Protect Overton Park (CPOC).
CPOC fought the city, state, and federal government for twenty-four years—until 1981,
when the Overton Park route was officially withdrawn. (2001)*

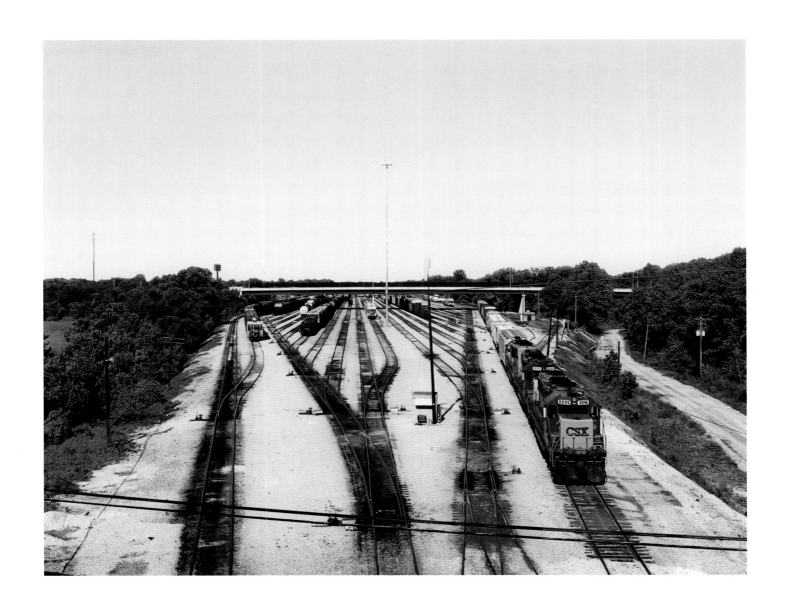

The tip of the Illinois Central Johnston Yards, seen here from Third Street just south of Nonconnah Creek, points up the importance of the transportation industry in Memphis. The city's origins and early commerce were based on Mississippi River transportation. Now Memphis has the second largest inland port on the lower Mississippi. The opening of the Frisco Bridge (page vi) in 1892 greatly increased railroad activity in Memphis, and today Memphis is served by five major railroads. There are also 163 truck terminals in Memphis, and, thanks to FedEx's Superhub, Memphis International Airport is the busiest cargo airport in the world. (2001)

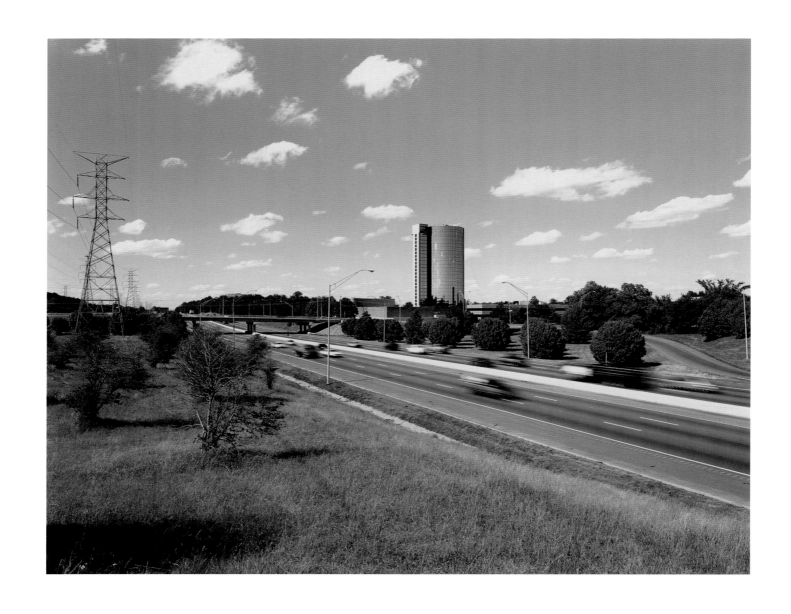

In 1958, construction began on the Interstate 40-240 loop, which was designed to encircle the expanded city.
This view is on the eastern loop of Interstate 240 at Poplar Avenue. In the center of the picture
is the Adam's Mark Hotel (built as the Hyatt Regency Hotel in 1974), a twenty-six-story
mirror-glass cylinder with an attached rectangular elevator tower. (2001)

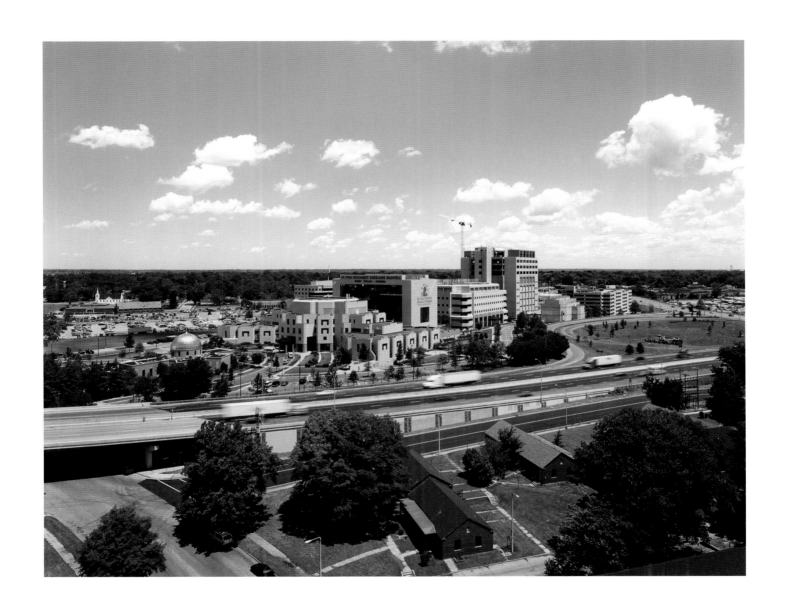

*Seen here from the Barry Homes high-rise (1972), St. Jude Children's Research Hospital campus spans fifty-three acres.
St. Jude, founded in 1962 by entertainer Danny Thomas (1914–1991), remains focused on catastrophic childhood diseases,
treating children regardless of a family's ability to pay. The complex is bounded on the south by I-40, shown with
truck traffic, and on the east by Danny Thomas Boulevard, on the far right. A section of Lauderdale Courts
Public Housing is in the foreground. Lauderdale Street is in the lower left. The white First Baptist
Church Chelsea, on the left horizon, is in the Greenlaw neighborhood. (2001)*

91

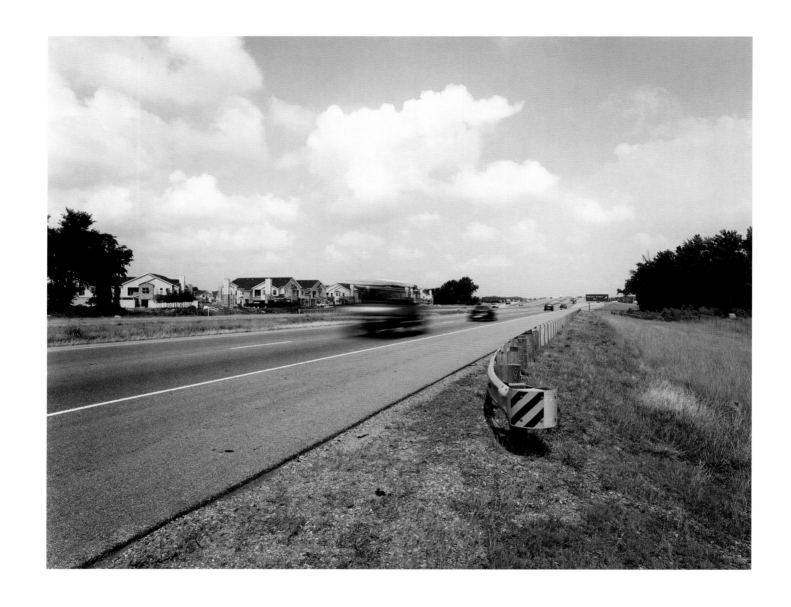

*Bill Morris (Nonconnah) Parkway is a 6.7-mile segment of Tennessee 385 between Riverdale and Bailey
Station roads that was completed expeditiously in 1997 to entice FedEx to build its World Technology Center in
Collierville. The 2000 census showed that more Memphians now live outside the Interstate 40-240 expressway loop
than live within it. The Bill Morris Parkway has facilitated that population shift; the southeastern part of Shelby County
has had the greatest growth. In this view of the parkway at Hacks Cross Road, Waterford Place Apartments,
with new units under construction, is on the left horizon. (2001)*

This house, built in 1999, is in the Grove Park neighborhood in Germantown. This neighborhood is near both the new FedEx World Tech Center, built in Collierville in 1998, and the new FedEx World Headquarters, built near Southwind in 2000. (2001)

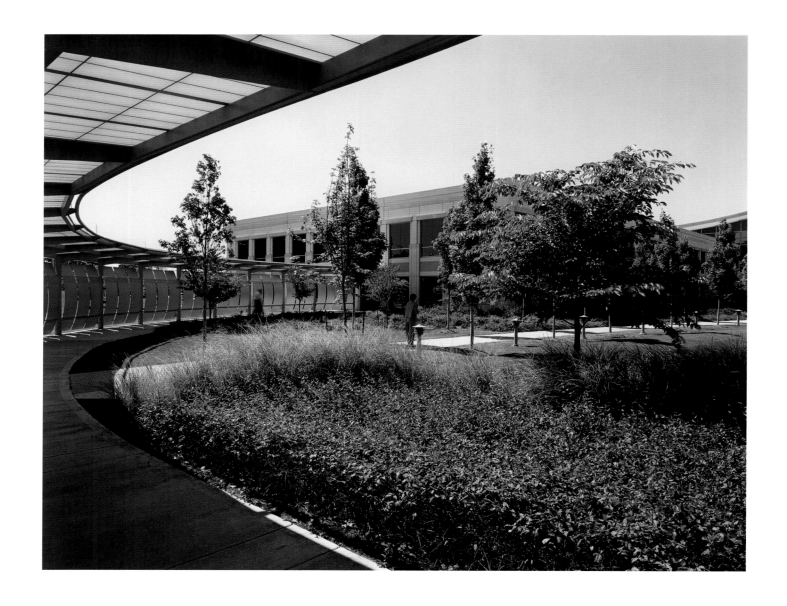

This courtyard, created like a formal garden, is at the FedEx World Technology Center in Collierville, on Bailey Station Road north of Bill Morris Parkway. One hundred and eighteen acres of farmland was transformed to become one of the leading-edge information technology (IT) centers in the United States. The facility houses nearly 3,000 of the corporation's IT employees. The campus features large, open natural areas and amenities that include fitness and retail centers, jogging trails, dry cleaning and car detailing services, an auditorium, and a restaurant. The design provides a productive, convenient, and motivating workplace. (2001)

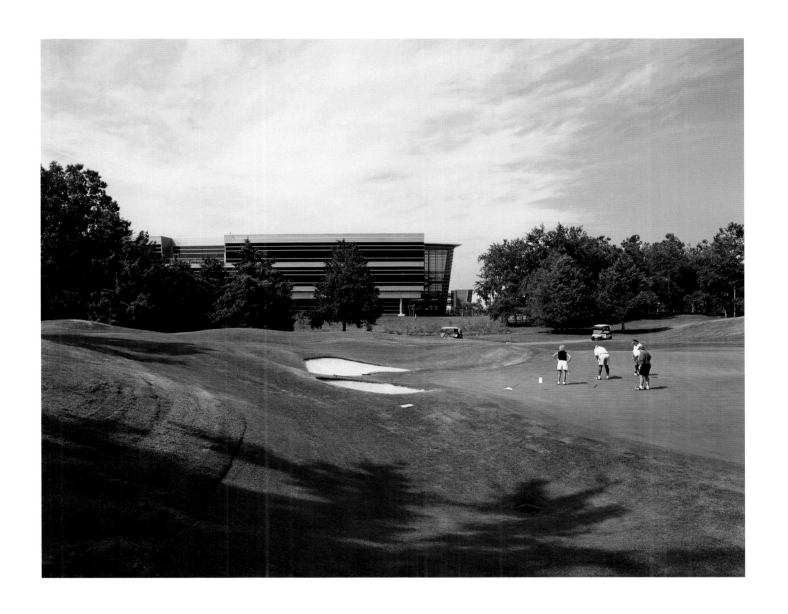

The Tournament Players Club at Southwind is near Winchester and Hacks Cross roads in southeast Shelby County. The building in the background of this view from the #4 green is part of the FedEx Express World Headquarters, completed in 2001. An eight-building, 1.1 million-square-foot complex on an eighty-nine-acre site bordering the golf course, the World Headquarters features many of the same amenities as the Technology Center, such as jogging trails, fitness and retail centers, and a five-hundred-seat auditorium. Southwind is the site of the annual FedEx/St. Jude golf classic, a PGA tournament that benefits St. Jude Children's Research Hospital. (2001)

95

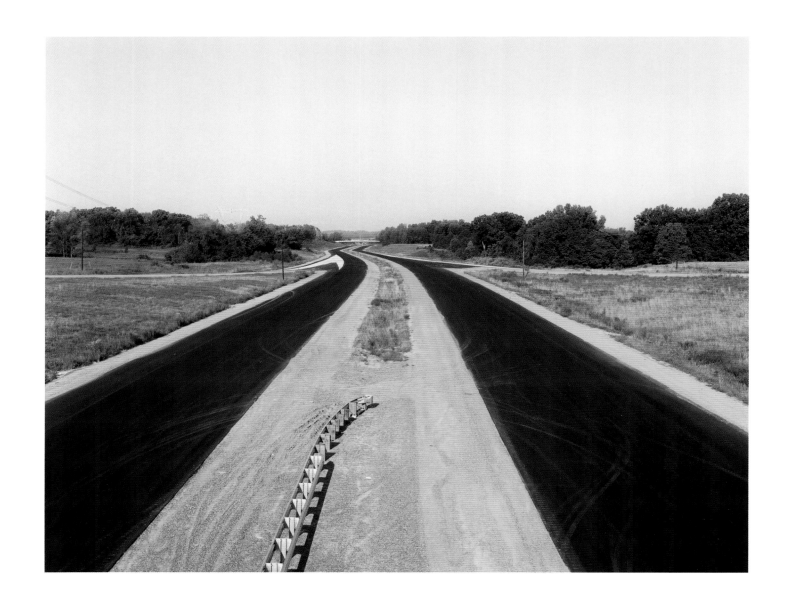

Seen from the Stewart Road overpass in northern Shelby County is a new section of Tennessee 385 called Paul Barret Parkway. The Collierville-Arlington Parkway, now in the engineering stages, is planned to connect Paul Barret Parkway on the north side and the Bill Morris (Nonconnah) Parkway on the south side into one expressway looping Shelby County's expanding urban area. "Memphis, which in terms of square mileage, is bigger than St. Louis, Atlanta, and Birmingham combined, is still growing, with abundant flat land that is relatively easy to develop," noted John Branston in a May 2000 article in Memphis *magazine. (1998)*

A house is being framed in the Davies Plantation neighborhood of Memphis, near Brunswick Road and I-40. The Davies Plantation was settled in 1830. (1998)

A new house on Corbitt Road in Fayette County as seen from Yager Drive. The Wolf River and the Ghost River State Natural Area are about one and one-half miles to the north. (1998)

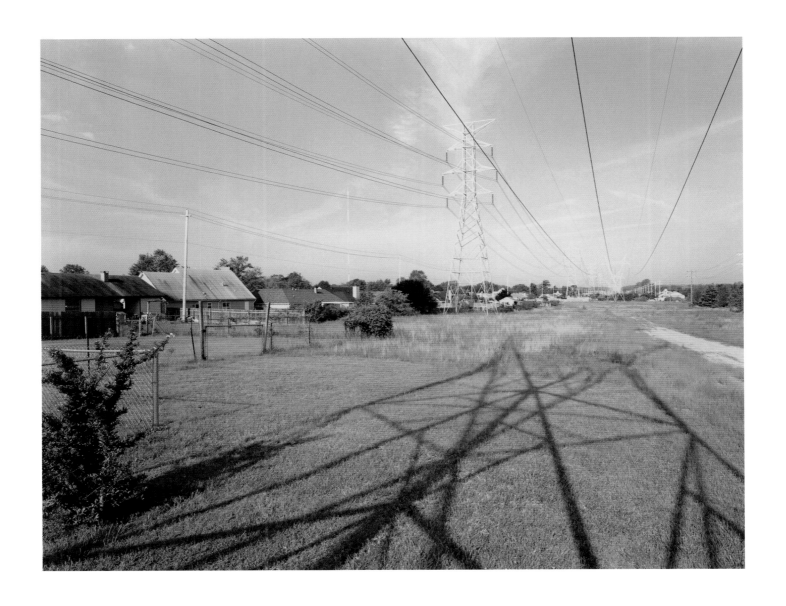

Transmission lines traverse this area just west of Appling Road and north of I-40. (1998)

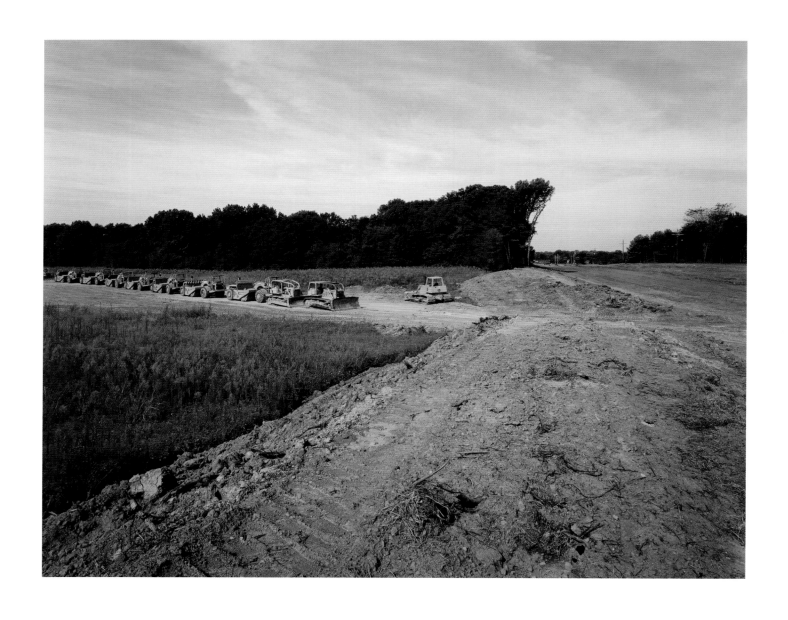

U.S. Highway 64 is widened near the Shelby/Fayette County line. (1991)

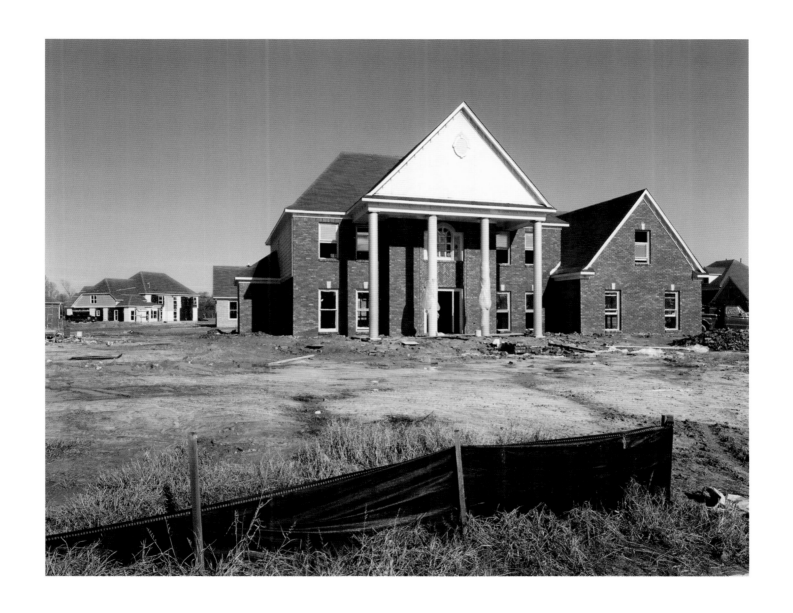

A new house under construction in the Wellington Farms neighborhood of Collierville.
Collierville, developed in the 1940s, has been a small, quiet town until recently.
This neighborhood is near both new FedEx complexes. (1998)

New construction in the Plantation Hills neighborhood of Lakeland. (1996)

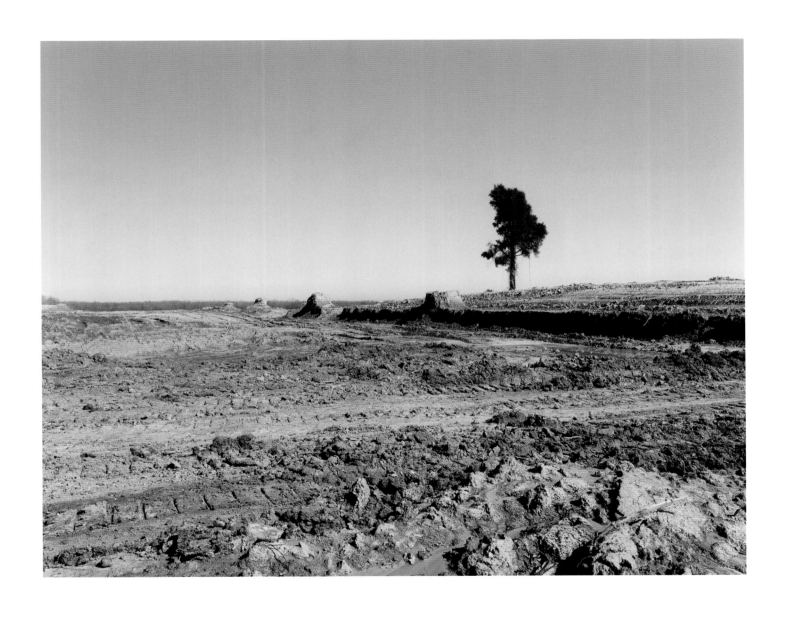

Farmland is being excavated to become the Abington Woods neighborhood north of Old Brownsville Road near Germantown Road in northeast Shelby County. (1998)

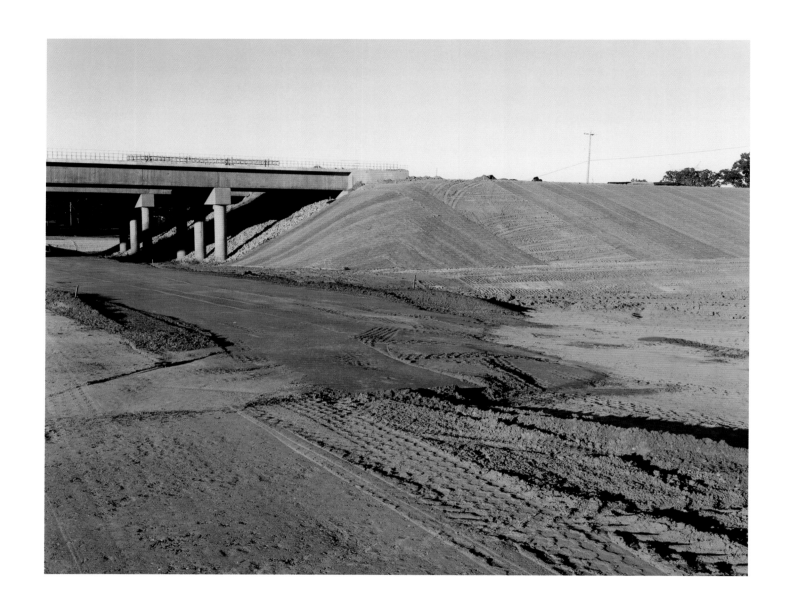

*Construction of the Paul Barret Parkway at the overpass above Brunswick Road
in northeast Shelby County. (1996)*

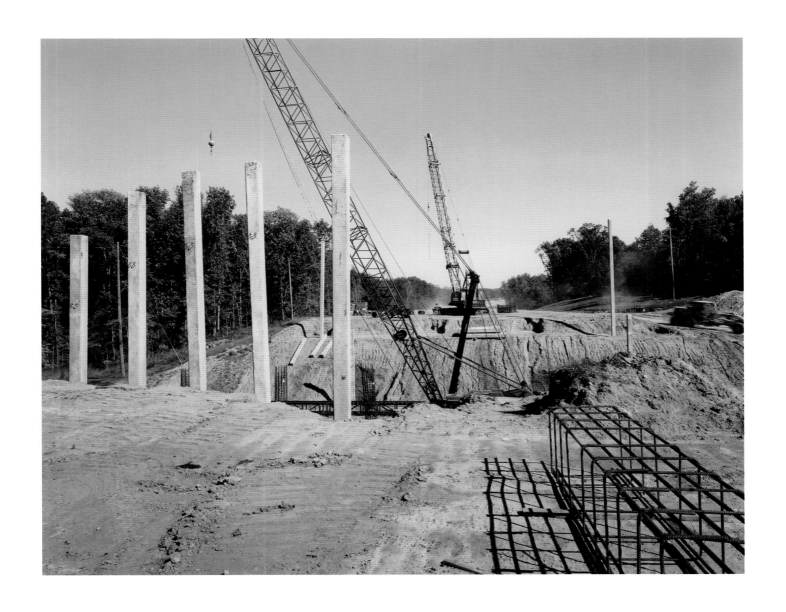

The overpass for Long Road along the Paul Barret Parkway in northeast Shelby County. (1996)

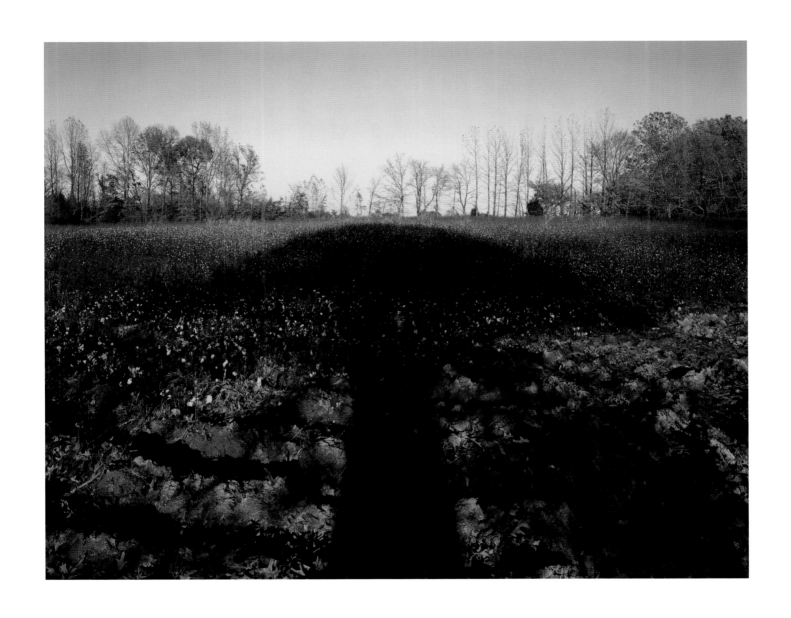

A tree casts its shadow in a cotton field near Bolton, Shelby County. (1992)

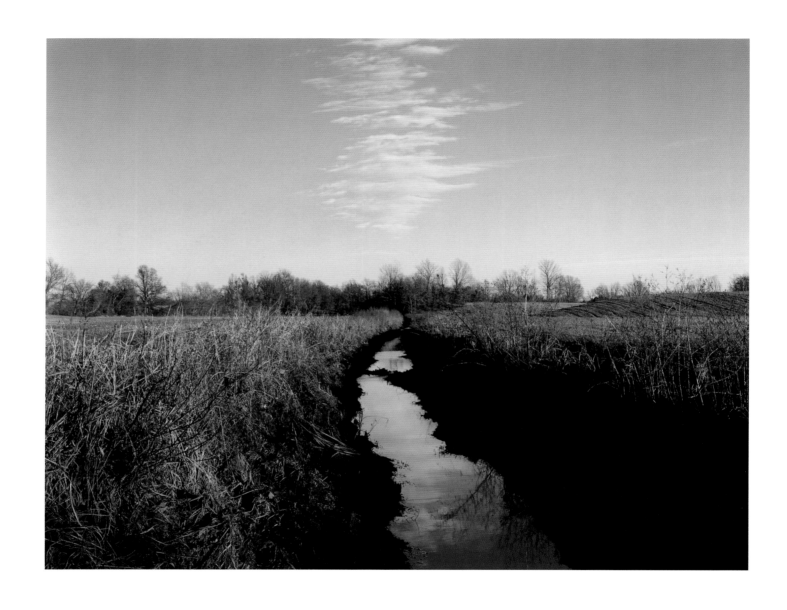

A drainage ditch in fields near Burlison, Tipton County. (1996)

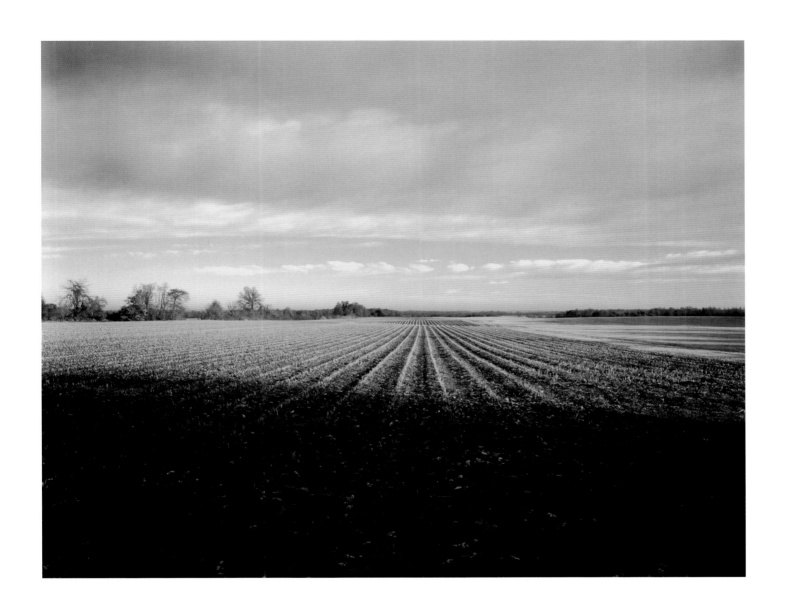

Cotton stubble near Bolton, Shelby County. (1994)

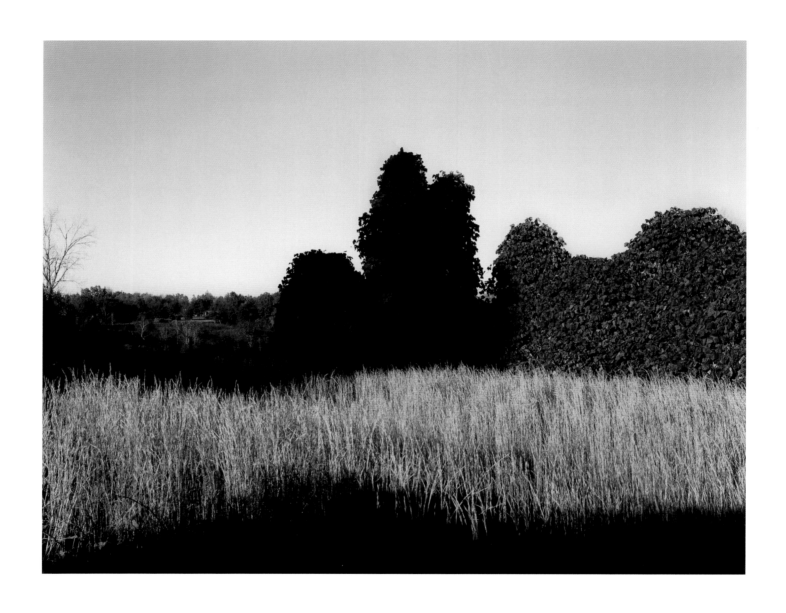

Kudzu-covered trees at the edge of a field near Burlison, Tipton County. (1996)

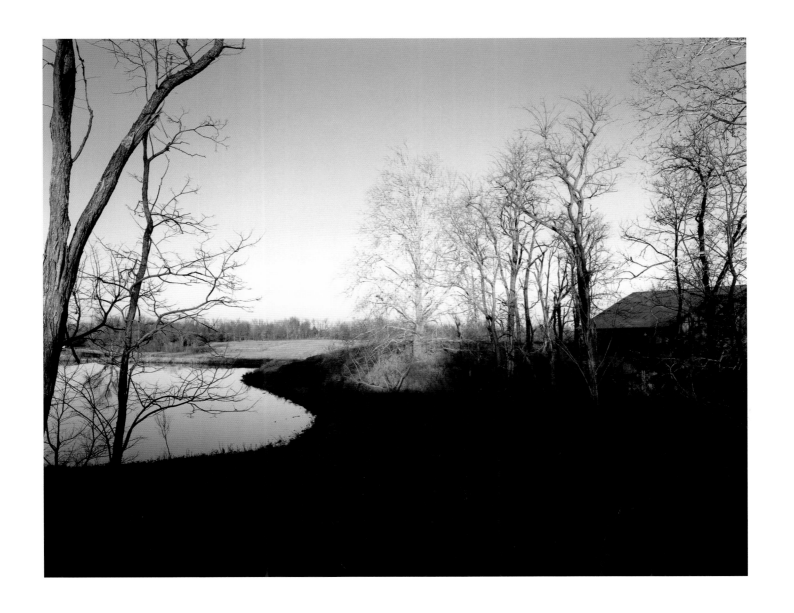

A farm pond in Tipton County. (1996)

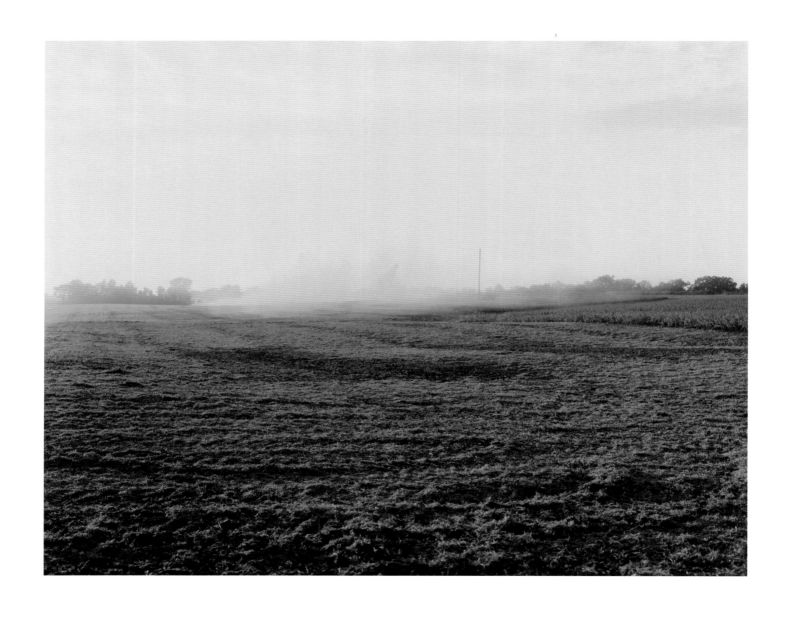

"You just love it. It's like loving your children; it's like you don't really have a choice."
"God gives you your love of your children; I guess it's the same way with your land."
—Brenda and Hugh Lee Waits, Tipton County soybean and cotton farmers. (1998)

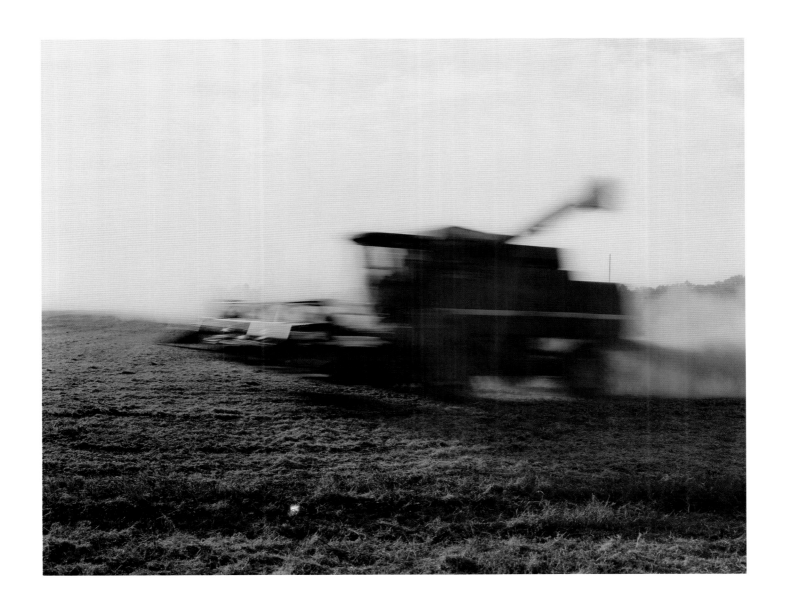

Soybeans are harvested in late afternoon at the corner of Church and Western Valley Roads near Garland in Tipton County. Cotton and soybeans are the dominant crops in West Tennessee. (1998)

Morning fog lifts from a wheat field off Russell Bond Road in Shelby County, west of Millington. (1998)

This farmed bottomland extends along the Mississippi River near where the Hatchie River joins it in Tipton County. Indian Creek Lane is on the left; a freshly planted field is on the right. (1994)

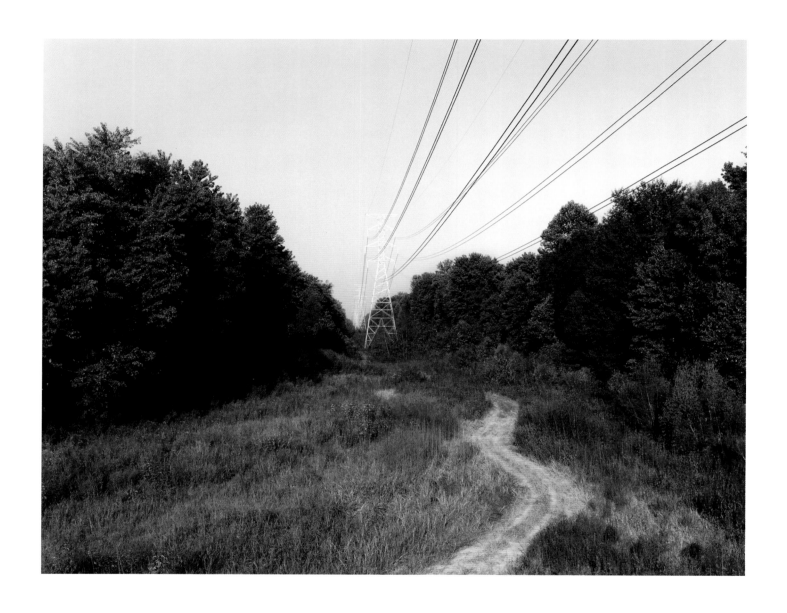

Transmission lines cut westward through the landscape, as seen here from the north end of the Brunswick Road bridge over the Loosahatchie River Canal, Shelby County. (1998)

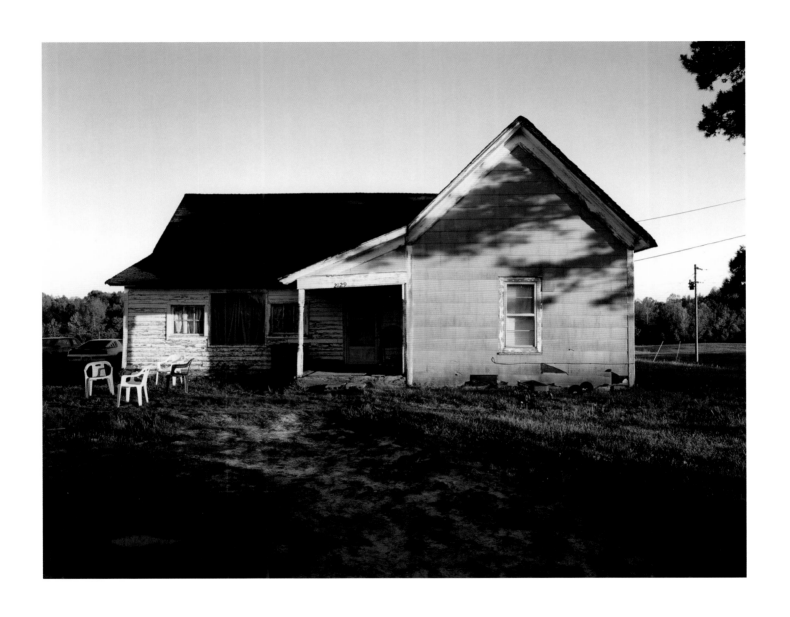

This house, built in 1918, faces McCormick Road in Tipton County, north of Millington. (1998)

Old cars surround a garage in the Boxtown neighborhood of Memphis, just south of T.O. Fuller State Park. (1998)

*During the 1920s, the Illinois Central Railroad had a switching yard, a railroad shop, and a facility for
the manufacture of boxcars south of the city. Timbers and planks used to hold machinery in place during transit,
other packing materials, and scraps from the boxcar manufacturing were all discarded there. These items were then
gathered by poor black people and used to build shanties near the railroad yard, and the area became known
as "Boxtown." This area wasn't annexed by the city until 1971, and it still has a rural ambience. (1998)*

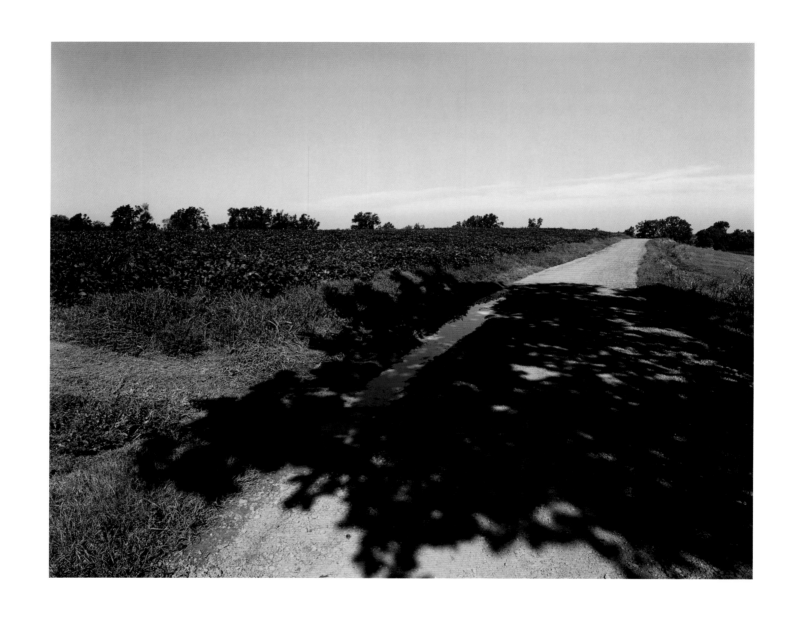

Detroit Drive leads to bottomland fields along the Hatchie River, Tipton County.
Left of the road is a cotton field at the midsummer stage. (1994)

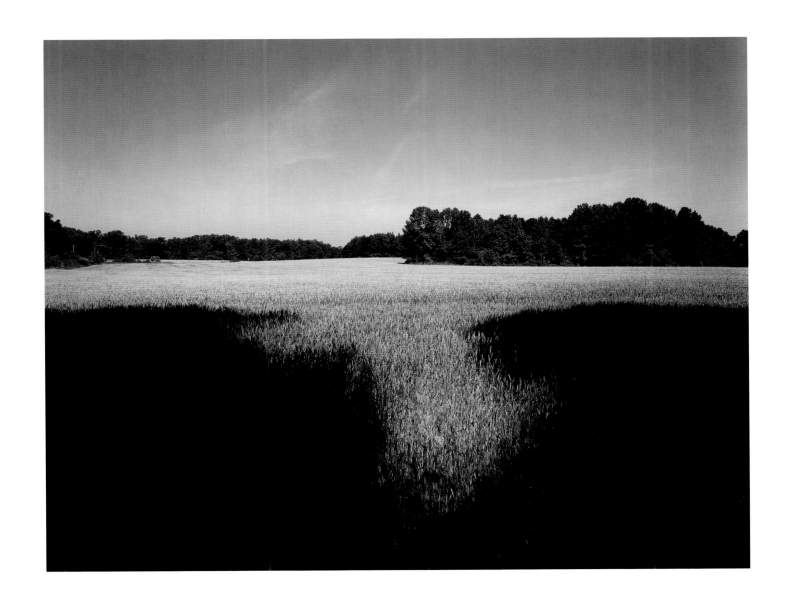

*A wheat field and woodlands at Old Brownsville and Evergreen roads
in northeast Shelby County. (1993)*

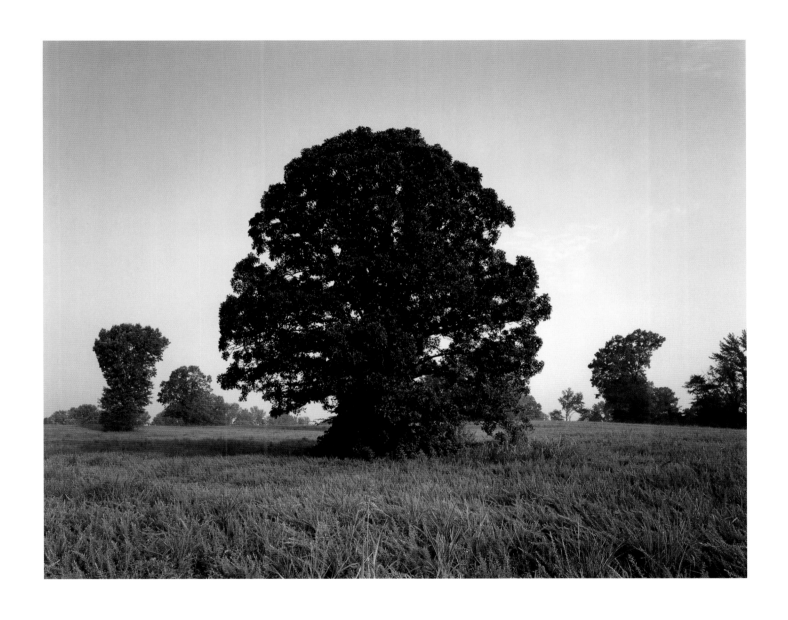

Oaks trees in an alfalfa field off Bragg Road near U. S. Highway 64 and the Shelby/Fayette County line. (1993)

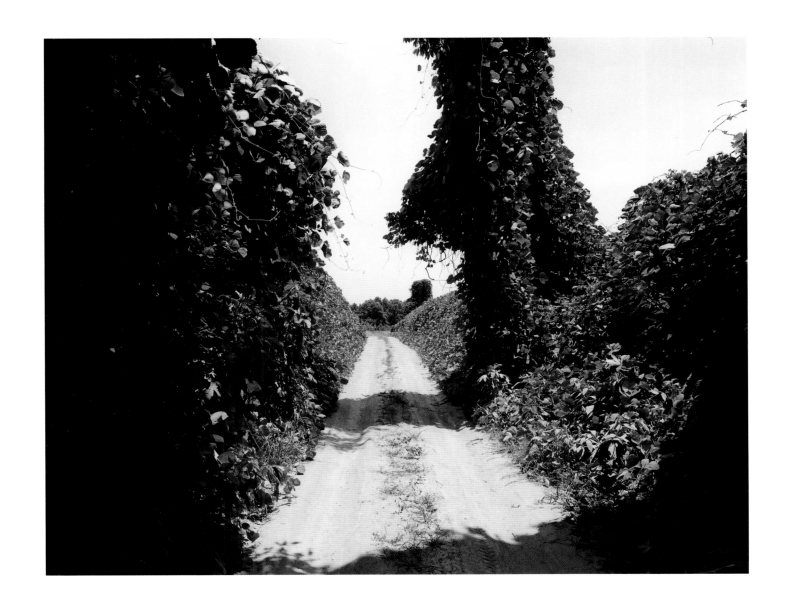

"Japan invades," begins James Dickey's poem, "Kudzu." Kudzu vines grow along St. Francis County Road 430, about forty miles west of Memphis on Crowley's Ridge in Arkansas. Crowley's Ridge is the first high land west of Memphis. Many thousands of years ago, the ridge separated the main valley of the Mississippi River on the west from the main valley of the Ohio River on the east. Crowley's Ridge forms an unbroken line running north and south for about 125 miles. Formed by windblown loess during the Pleistocene, its form and features are similar to the Chickasaw Bluffs in West Tennessee. (1998)

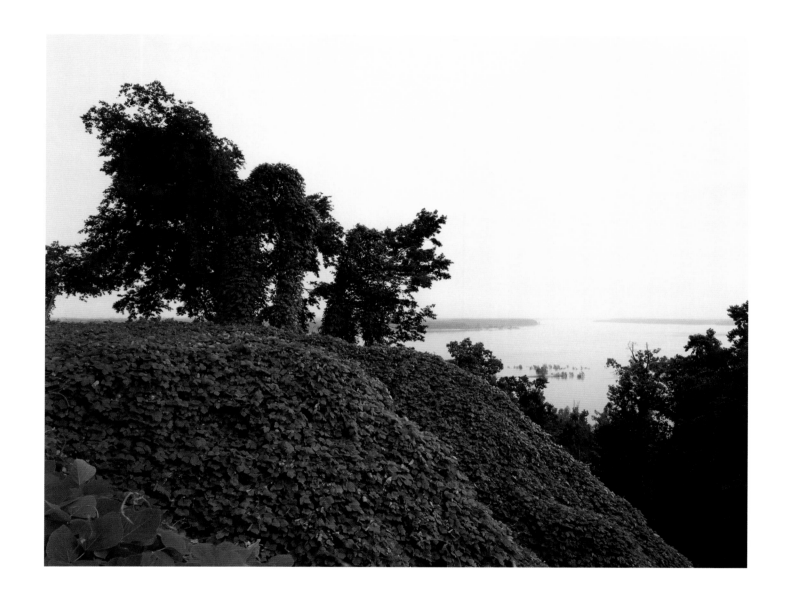

*The entire line of hills parallel to the Mississippi River flood plain in West Tennessee is referred to as the "Chickasaw Bluff,"
after the Native American people who occupied the area. Also, early travelers on the river named the locations where
the river channel came right up to the bluff line. They numbered these spots in the order seen as they came down the river.
Chickasaw Bluff #1 was at Fort Pillow; #2 was just south of the Hatchie River; #3 was about where Shelby Forest is now;
and #4, also called the Lower Chickasaw Bluff, was where Memphis is now. The Mississippi River channel has a strong
tendency to change locations. Chickasaw Bluff #2 and #4 are still on the main channel; #1 and #3 are not. (1998)*

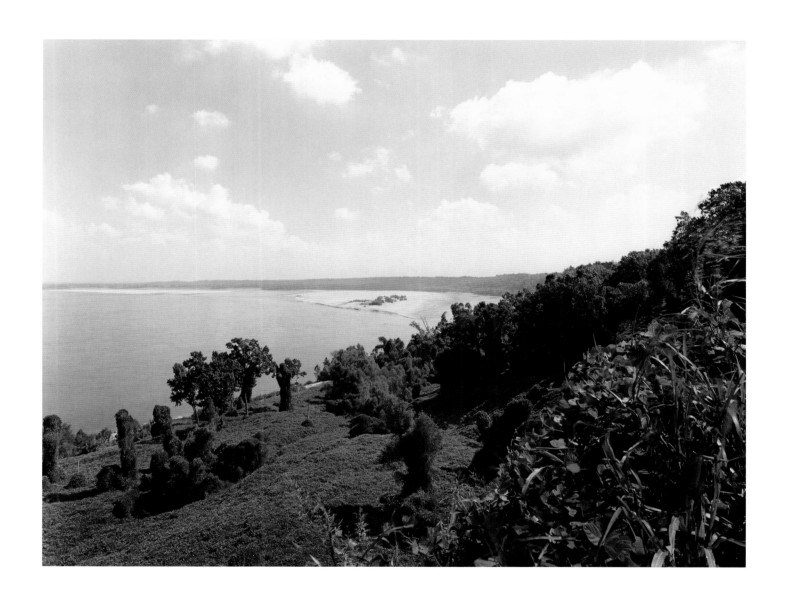

The two views of the Mississippi River here and on page 126, are from different vantage points on Chickasaw Bluff #2. Chickasaw Bluff #2 is covered with kudzu. A native of Asia, kudzu is a weedy vine with rampant invasive growth that can cover anything in its path. It was brought to the South in the 1930s to control erosion but is now considered a nuisance weed. (1998)

Recreational boaters take to the water of the Mississippi River just below Duval Landing, Tipton County. (1997)

A willow grove along the Mississippi River south of Duvall Landing, Tipton County. (1997)

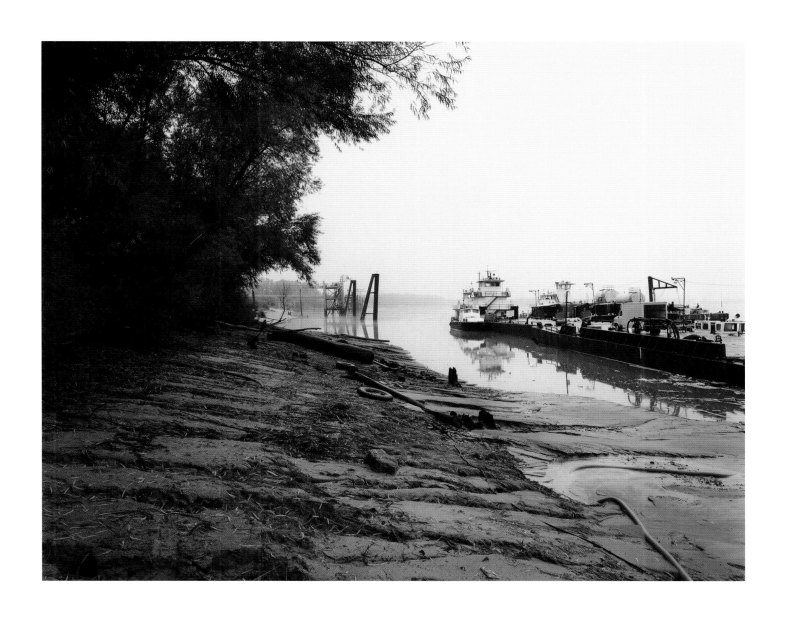

Commercial river boats dock near the Memphis-Arkansas Bridge. (1996)

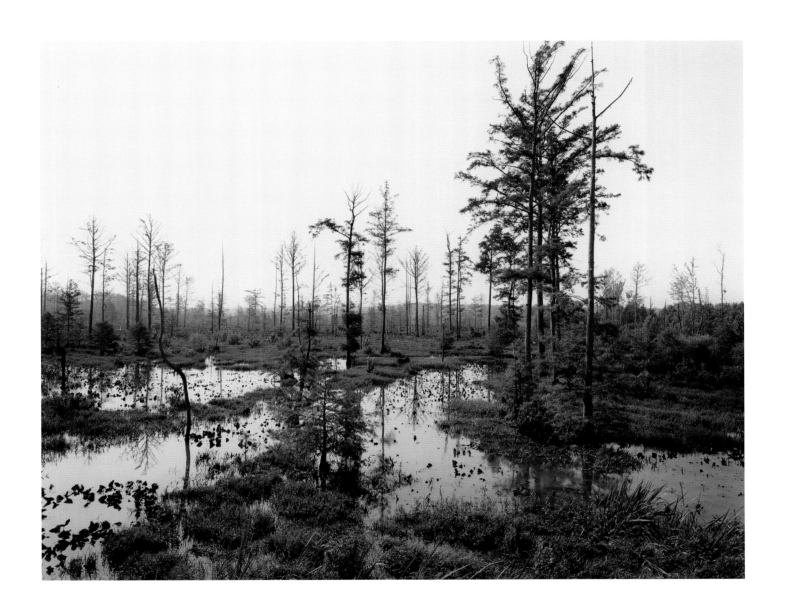

Bald cypress grow in an open marsh on the Wolf River near the Bateman Road bridge in Fayette County.
The bald cypress are the largest trees in the area, growing 100 to 150 feet high. Their trunks are enlarged
at the base and in the swamps the submerged roots grow cone-shaped "knees" which project up
into the air for "breathing." (1998)

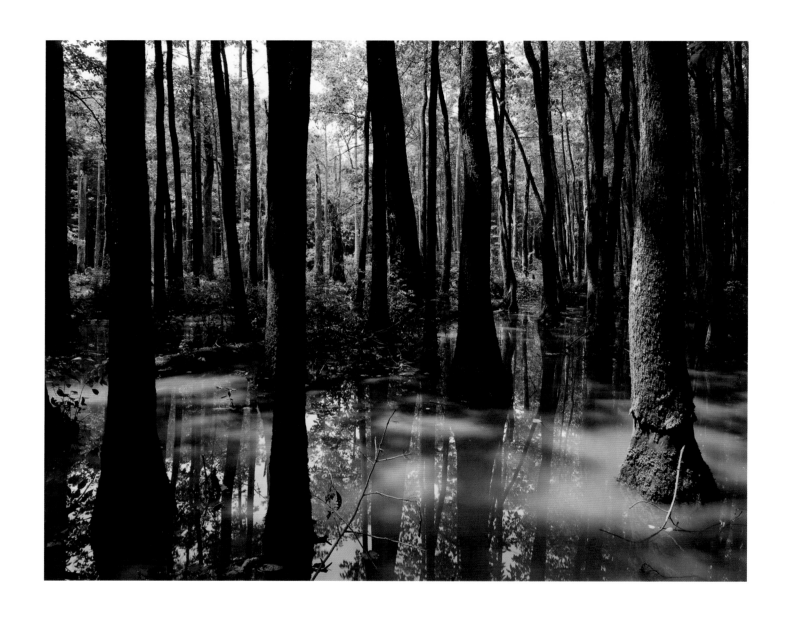

The water tupelo and bald cypress swamp in the Ghost River section almost fell prey to encroaching development. (1998)

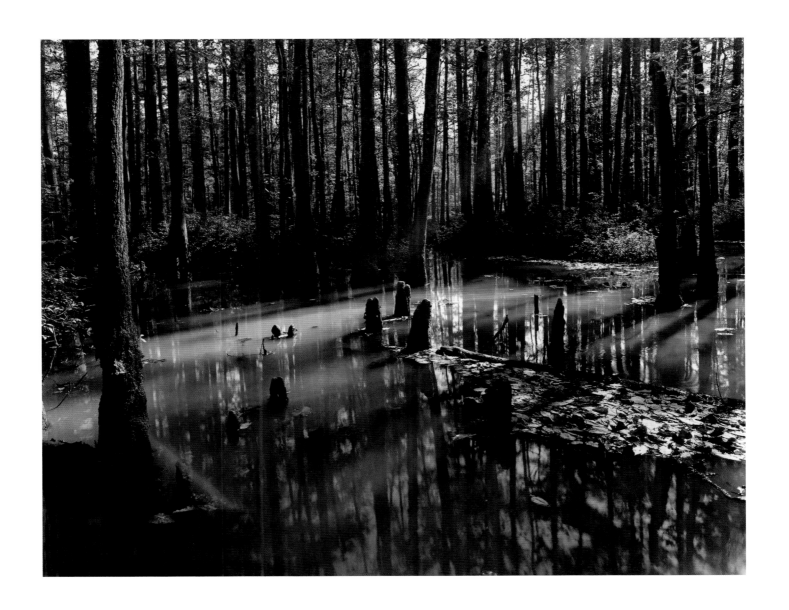

In the mid-1990s, the Wolf River Conservancy led a fight to save this pristine Ghost River area when the 4,000-acre
Beasely Farm, which encompassed the swamp, was purchased by a company that intended to auction it for timber
harvesting and housing development. The Wolf River Conservancy began a campaign to raise money to buy
the entire farm. Miraculously, through a combination of individual pledges, state funds, and private loans,
enough money was raised in time to save the farm. Since then other adjacent wetlands and forests
have been added to it to form the 6,500-acre Ghost River State Natural Area. (1998)

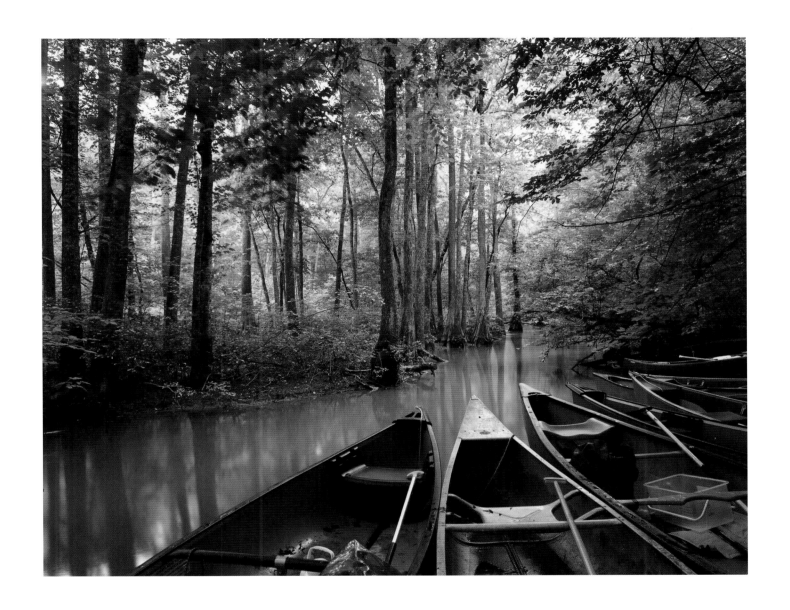

The Ghost River section of the Wolf River is "one of the premier wilderness canoe trails in the East,"
writes Parke Puterbaugh in Southeastern Wetlands. *It is approximately an hour's drive east of Memphis,*
with canoe launching sites near the towns of Moscow and LaGrange in Fayette County. Several natural wetland
environments can be found there. This view is midway on the trail in the midst of the swamp,
a place where local canoeists traditionally stop for lunch. (1998)

137

Books

General interest about Memphis or the region:

Aiken, Charles S. *The Cotton Plantation South since the Civil War.* Baltimore: John Hopkins University Press, 1998. This award-winning book is a *tour de force* of information, interpretation, and comprehension of the cotton region—its economy, society, and history. It is the first book to show how the civil rights movement grew directly out of the geography of the plantation system.

Barry, John M. *Rising Tide: The Great Mississippi Flood of 1927 and How It Changed America.* New York: Simon & Schuster Inc., 1997. This American epic of science, politics, and race is a superb presentation of the complexities and significance of the Mississippi River.

Beifuss, Joan Turner. *At The River I Stand*, rev. trade edition. Memphis: St. Lukes Press, 1990. This book is about the 1968 sanitation workers strike in Memphis that led to the assassination of Dr. Martin Luther King, Jr.

Beifuss, Joan Turner (foreword by). *I Am A Man: Photographs of the 1968 Memphis Sanitation Strike and Dr. Martin Luther King, Jr.*, rev. trade edition. Memphis: Memphis Publishing Co., 1993.

Capers, Gerald M. Jr. *The Biography of a River Town: Memphis—Its Heroic Age*, 2nd edition. Memphis: Burke's Book Store, 1980. This is a comprehensive outline of the history of Memphis before 1900.

Clayton, Lawrence A.; Knight, Jr., Vernon James; and Moore, Edward C. Moore; editors. *The De Soto Chronicles: The Expedition of Hernando de Soto to North America in 1539–1543.* Tuscaloosa: University of Alabama, 1993, Vol I and II. This work is a complete collection of the chronicles for the De Soto expedition into the southeastern United States.

Coppock, Paul. *Memphis Sketches.* Memphis: Friends of the Library, 1976. Paul Coppock, a reporter and editor at *The Commercial Appeal* from 1928 to 1983, became known as the man who knew more about the area's history than any other person. His carefully researched articles about Memphis and Mid-South history are considered accurate. *Memphis Sketches, Memphis Memoirs,* and the four volumes of *Paul R. Coppock's Mid-south* are collections of his historical articles for the newspaper.

Selected Readings, Recordings, Videos, and Web Sites

Coppock, Paul. *Memphis Memoirs*. Memphis: Memphis State University Press, 1980.

Coppock, Helen and Charles W. Crawford, eds. *Paul R. Coppock's Mid-South*, vols. 1–4. Nashville: Williams Printing, 1985–1994.

Crawford, Charles Wann. *Yesterday's Memphis*. Miami: E. A. Seeman, 1976. This is a general history, with illustrations and photographs, of Memphis from its beginning to the mid 1950s.

DePaoli, Geri and Wendy McDaris. *Elvis + Marilyn: 2x Immortal*. New York: Rizzoli International Publications, 1994.

Dougan, John. *Memphis*. Charleston, SC: Arcadia, 1998. Using 200 historic photographs with captions, this book traces the development of Memphis from its redevelopment after the 1870s Yellow Fever epidemic to the end of World War II.

Duncan, David Ewing. *Hernando de Soto: a savage quest in the Americas*. New York: Crown Publishers, 1995. This book is a good place to begin learning about De Soto and his expedition.

Eads, James Buchanan, 1820–1887; and McHenry, Estill (compiled and edited by). *Addresses and papers of James B. Eads, together with a biographical sketch*. St. Louis: Slawson and Company, 1884.

Harkins, John E., with an introduction by Edward F. Williams. *Metropolis of the American Nile: An Illustrated History of Memphis and Shelby County*. Oxford, MS: Guild Bindery Press, 1991. This is a basic and accessible history of Memphis from 1541 to 1991.

Hudson, Charles M. *The Southeastern Indians*. Knoxville: University of Tennessee Press, 1976. This is a very readable introduction to the culture, society, prehistory, and history of native people of the southeastern United States.

Hudson, Charles M. *Knights of Spain, Warriors of the Sun: Hernando De Soto and the South's ancient chiefdoms*. Athens: University of Georgia Press, 1997. In this book Hudson constructs a revised route for the De Soto Expedition of 1539–1542, placing it on a map and, in many instances, tying it to specific archaeological sites.

Hyland, Stanley E., Janis foster, and Mary Richardson. *Memphis Neighborhood Timeline: An Anthropological Perspective On community Building: A Work In Progress*. Memphis, TN: Department of Anthropology, University of Memphis, 1996.

Johnson, Eugene J. and Robert D. Russell, Jr. *Memphis: An Architectural Guide*. Knoxville: University of Tennessee Press, 1990. This guide has descriptions of some 550 buildings, together with 250 photographs and detailed maps. It also includes brief histories of Memphis and its architectural development and has informative entries about neighborhoods and buildings.

King, Jr., Martin Luther. *Strength To Love*. New York: Harper & Row, 1963.

Lee, George Washington, foreword by W.C. Handy. *Beale Street, Where the Blues Began*. New York, 1934. 2d ed., College Park, MD, 1969. The author, a prominent black Memphian, was during his career an Army lieutenant, a wealthy Memphis businessman, a novelist, and an important Republican politician. He was friends with W.C. Handy and the others he writes about in this account of legendary Beale Street.

Magness, Perre. *Good Abode: Nineteenth Centrury Architectrue in Memphis and Shelby County, Tennessee.* Memphis: Junior League of Memphis: Towery Press, 1983.

Magness, Perre. *Past Times: Stories of Early Memphis.* Memphis: Parkway Press, 1994.

McDaris, Wendy. *Visualizing the Blues: Images of the American South.* Memphis: The Dixon Gallery and Gardens, 2001.

Miller, William D. *Mr. Crump of Memphis.* Baton Rouge: Louisiana State University Press, 1964. This is an in-depth, sympathetic but not uncritical portrait of Edward H. Crump who became mayor of Memphis in 1910 and was Memphis political "boss" until his death in 1954.

Moe, Richard and Carter Wilkie. *Changing Places: Rebuilding Community in the Age of Sprawl.* New York: Henry Holt and Co., 1997. This is an argument for the preservation of city centers in a time of ex-urbanization and suburbanization. It is a critique against sprawl which suggests alternatives. A chapter on Memphis is very informative.

Morgan, William. *Collegiate Gothic: the Architecture of Rhodes College.* Columbia: University of Missouri Press, 1989.

Raichelson, Richard M. *Beale Street Talks: A Walking Tour Down the Home of the Blues,* 2nd edition. Memphis, TN: Arcadia Records, 1999. This guidebook outlines the history and architecture of each building along historic Beale Street as it was in its heyday.

Saucier, Roger T. *Geomorphology and Quaternary Geologic History of the Lower Mississippi Valley,* prepared by Roger T. Saucier for the President, Mississippi River Commission. Vicksburg, MS: U.S. Army Corps of Engineers, Waterways Experiment Station, 1994.

Sigafoos, Robert A. *Cotton Row to Beale Street: A Business History of Memphis.* Memphis: Memphis State University Press, 1979. This book covers Memphis business and urban land development from its pioneer origins up to 1979.

Sorrels, William Wright. *Memphis' Greatest Debate: A Question of Water.* Memphis: Memphis State University Press, 1970. This history traces the various sources used by Memphians for their water, and the politics leading to the purchase of the Artesian Water Company by the city of Memphis.

Taylor, Peter. *The Old Forest and Other Stories.* Garden City, NY: Dial Press, 1985. A great literary work.

Weeks, Linton. *Memphis: A Folk History.* Little Rock: Parkhurst, 1982.

Wilson, Charles Reagan and William Ferris (editors). *Encyclopedia of Southern Culture.* Chapel Hill: University of North Carolina Press, 1989.

Withers, Ernest C. *Pictures tell the story: Ernest C. Withers reflections in history: with contributions by F. Jack Hurley, Brooks Johnson, Daniel J. Woolf.* Norfolk, VA: Chrysler Museum of Art, 2000. This book includes civil rights events in Memphis as photographed by a black photographer.

The WPA guide to Tennessee: Compiled and Written by the Federal Writer's Project of the Works Progress Administration for the State of Tennessee (1939); With a New Introduction by Jerrold Hirsch

and a foreword by Wilma Dykeman. Knoxville: University of Tennessee Press, 1986. This work, which has a section on Memphis, evokes the distinctive qualities of both the place and the writers' attitudes in the late 1930s.

Memphis Music

Escott, Colin and Martin Hawkins, *Good Rockin' Tonight: Sun Records and the Birth of Rock 'N' Roll.* New York: St. Martin's Press, 1991. B. B. King, Howlin' Wolf, Ike Turner, Rufus Thomas, Elvis Presley, Johnny Cash, Jerry Lee Lewis, Carl Perkins, Charlie Rich, and Roy Orbison all got their start at Sun Records. This is a story in words and pictures of Sun Records and its founder, producer Sam Phillips.

Gordon, Robert. *It Came from Memphis.* Winchester, MA: Faber and Faber, 1995. This book does not focus on Elvis Presley, Al Green, Sun and Stax studios. It is an anecdotal, digressive, informative, and entertaining history of rock and roll's hometown.

Guralnick, Peter. *Sweet Soul Music: Rhythm and Blues and the Southern Dream of Freedom.* New York: Harper & Row, 1986. This is a history of 1960's soul music and the rise and fall of Stax Records that provides rich detail about the music, business dealings, personalities, race relations, and the culture of the period.

Handy, W. C. (William Christopher). *Father of the Blues: An Autobiography.* New York: Macmillan Company, 1941. Handy's remarkable tale—pervaded with his unique personality and humor—reveals not only the career of the man who brought the blues to the world's attention, but also the whole scope of American music, from the days of the old popular songs of the South, through ragtime to the great era of jazz.

Lornell, Kip. *Happy in the Service of the Lord: African-American Sacred Vocal Harmony Quartets in Memphis,* 2nd edition. Knoxville: University of Tennessee Press, 1995. This book provides an in-depth look at the development of the African-American gospel quartet and its contribution to the cultural and musical identity of Memphis.

Palmer, Robert. *Deep Blues.* New York: Viking Press, 1981. A first-rate study of the blues styles and major performers of the Mississippi Delta. Personal histories of great bluesmen trace the evolution of the blues from Africa to the Mississippi Delta.

Recordings

All albums are one CD unless otherwise noted.

Early influential blues:

W. C. Handy, *W. C. Handy's Memphis Blues Band* (recorded 1917–1923) (Memphis Archives MA7006)

Furry Lewis, *In His Prime 1927–1928* (Yazoo 1050)

Memphis Jug Band (recorded 1927–1934) (Yazoo 1067)

Robert Johnson, *The Complete Recordings* (recorded 1936–1937) (Columbia/Legacy C2K 64916—2CD)

Southern Journey, Vol. 3: 61 Highway Mississippi—Delta Country Blues, Spirituals, Work Songs & Dance Music (recorded 1959 by Alan Lomax) (Rounder 1703)

B. B. King, *Live at the Regal* (recorded 1964) (MCA 11646): A classic live album that also includes some of the songs he played in Memphis in the 1950s.

Memphis Rock'n'Roll:

Elvis Presley, *The Sun Sessions CD* (recorded 1954–1955) (RCA 6414-2-R)

Dewey Phillips, *Red, Hot & Blue: Live radio Broadcasts from 1952–1964* (Memphis Archives MA7016)

James Luther Dickinson, *Dixie Fried* (recorded 1971)(Atlantic 8299)

Legendary Memphis Studios and Labels:

Sun Studio, *The Sun Records Collection* (Rhino 71780—3CD): An overview of the seminal and influential blues, R&B, hillbilly, and rockabilly music recorded between 1950 and 1966 by Sam Phillips.

Stax Studio, *Top of the Stax: 20 Greatest Hits* (soul classics recorded 1960s and 1970s) (Fantasy/Stax 88005)

Hi Studio, *The Hi Records Story* (R&B and soul classics recorded 1960s and 1970s) (Denon Records HIUKCD101)

Gospel:

Brewsteraires, Songbirds of the South, Spirit of Memphis Quartet & others, *Bless My Bones—Memphis Gospel Radio, The Fifties* (Rounder 2063—Cassette)

Happy In the Service of the Lord: Memphis Gospel Quartet Heritage—the 1980s, Vol. 1 and Vol. 2 (Highwater Records Vol. 1, HMG 6516; Vol. 2, HMG 6517)

Jazz:

Phineas Newborn Jr., *A World of Piano* (original release 1961)(Fantasy/Original Jazz Classics 175)

Videos

At the River I Stand is a documentary by David Appleby, Allison Graham, and Steven John Ross, 1993, and distributed by California Newsreel, San Francisco, CA. It reconstructs the two eventful months in the spring of 1968 which led to the tragic death of Dr. Martin Luther King, Jr. and the dramatic climax of the Civil Rights Movement.

Black Diamonds, Blues City is a documentary written and directed by Steven John Ross, 1997, and distributed by Southern Culture Catalog, The University of Mississippi, University, MS. This film tells the story of Negro League baseball and especially the Memphis Red Sox in the Jim Crow era of the South.

Deep Blues is a documentary by Robert Mugge, 1991, and is available in video and DVD. Mugge teamed up with the noted music scholar Robert Palmer, whose seminal book provides the film's title, to capture modern-day blues survivors and inheritors playing in the bars, juke joints, and barns of the Mississippi Delta.

Mystery Train is a feature directed by Jim Jarmusch, 1989, available in video and DVD. It is a quirky, offbeat trio of vignettes about tourists' misadventures in Memphis.

Web sites

The following Web sites have information about Memphis. Several of these sites, particularly *Memphis Links* and *The Memphis Shelby County Public Library*, have links to other useful sites. The *Memphis Rock 'N' Soul Museum* site has links to many sites about Memphis music.

City of Memphis - www.ci.memphis.tn.us/

Memphis Links - www.ci.memphis.tn.us/links/main.cfm

Shelby County Government - www.co.shelby.tn.us/

The Commercial Appeal - www.gomemphis.com

The Memphis Flyer - www.memphisflyer.com

The Memphis Rock 'N' Soul Museum - www.memphisrocknsoul.org

The Memphis Shelby County Public Library - www.memphislibrary.lib.tn.us/

The University of Memphis - www.memphis.edu

Wolf River Conservancy - www.wolfriver.org

Lisa Kurts Gallery - www.lisakurts.com

Center for the Study of Southern Culture - www.olemiss.edu/depts/south/

Center for American Places - www.americanplaces.org

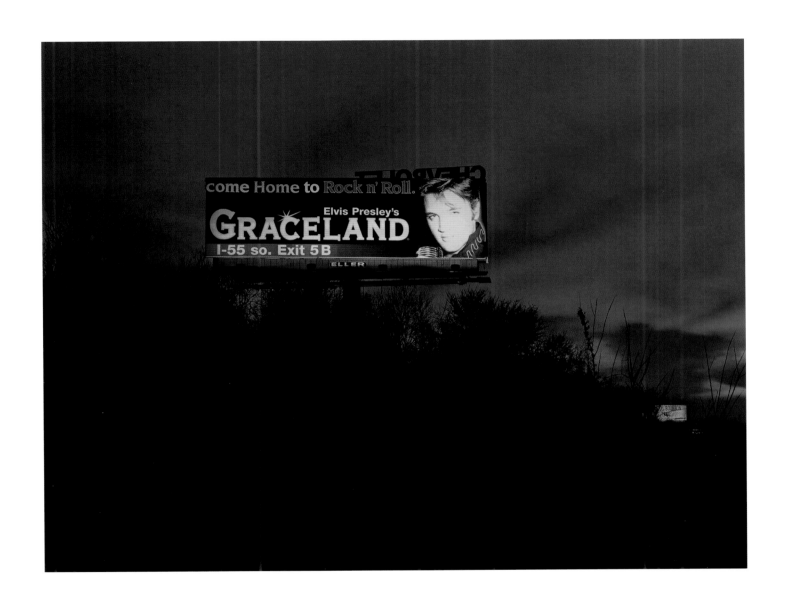

Westbound along Interstate 240 (south loop) near Getwell Road. (1999)

A tree ladder marks a swimming hole on the Wolf River at the Yager Drive bridge near LaGrange. From its beginnings near Michigan City, Mississippi, the Wolf River extends for eighty-six miles through Tippah and Benton counties in Mississippi and Fayette and Shelby counties in Tennessee. In Shelby County, it runs past the north side of Collierville and Germantown and through the north side of Memphis to its mouth on the Mississippi River— just north of the Pyramid. Since 1985 the Wolf River Conservancy has had the goal of linking the land that borders the entire length of the river into a continuous, protected greenbelt. (1998)

LARRY E. MCPHERSON was born in Newark, Ohio, in 1943. He received an M.A. in photography from Northern Illinois University in Dekalb and has taught since 1978 at the University of Memphis, where he is an associate professor of art. He has received two National Endowment for the Arts Fellowships in Photography (1975 and 1979), a Guggenheim Fellowship in Photography (1980), and a Tennessee Arts Commission Fellowship in Photography (1996). His photographs have been exhibited widely in the United States and Europe, and they are in the permanent collections of numerous institutions, including the Art Institute of Chicago, the Dayton Art Institute, the New Orleans Museum of Art, the Museum of Fine Arts in Houston, the International Museum of Photography in Rochester, New York, and the Museum of Modern Art in New York City.

CHARLES REAGAN WILSON is director of the Center for the Study of Southern Culture and professor of history at the University of Mississippi. He received his doctorate in history from the University of Texas at Austin and taught at the University of Wuerzburg in Germany, the University of Texas at El Paso, and Texas Tech University before coming to Mississippi in 1981. He is the coeditor of the *Encyclopedia of Southern Culture* (1989) and *The South and the Caribbean* (2001) and author of *Judgment and Grace in Dixie: Southern Faiths from Faulkner to Elvis* (1995) and *Baptized in Blood: The Religion of the Lost Cause* (1983).

About the Photographer and Essayist

THE CENTER FOR AMERICAN PLACES is a tax-exempt 501(c)(3) nonprofit organization, founded in 1990, whose educational mission is to enhance the public's understanding of, and appreciation for, the natural and built environment. It is guided by the belief that books provide an indispensible foundation for comprehending—and caring for—the places where we live, work, and explore. Books live. Books endure. Books make a difference. Books are gifts to civilization.

With offices in New Mexico and Virginia, Center editors bring to publication 20–25 books per year under the Center's own imprint or in association with its publishing partners. The Center is also engaged in numerous other programs that emphasize the interpretation of *place* through art, literature, scholarship, exhibitions, and field research. The Center's Cotton Mather Library in Arthur, Nebraska, its Martha A. Strawn Photographic Library in Davidson, North Carolina, and a 10-acre reserve along the Santa Fe River in Florida are available as retreats upon request.

The Center strives every day to make a difference through books, research, and education. For more information, please send inquiries to P. O. Box 23225, Santa Fe, NM 87502, U.S.A. or visit the Center's Web site (*www.americanplaces.org*).

ABOUT THE BOOK:

The text for *Memphis* was set in Adobe Minion, a typeface designed in 1990 by Robert Slimbach. The paper is acid-free Silk Mediaprint paper, 150 gsm weight. The four-color separations, printing, and binding were professionally rendered by Oddi Printing Ltd., of Reykjavik, Iceland.

FOR THE CENTER FOR AMERICAN PLACES:

George F. Thompson, president and publishing director

Randall B. Jones, editor and publishing liaison

David Skolkin, of Santa Fe, New Mexico, designer and typesetter

Charles B. Gershwin, of Wyncote, Pennsylvania, production coordinator

FOR THE UNIVERSITY PRESS OF MISSISSIPPI:

Seetha Srinivasan, director
Anne Stascavage, manuscript editing
John A. Langston, design and production